W9-BLX-365

The Black Market

A Guide to Art Collecting

Charles Moore

The Black Market: A Guide to Art Collecting

Published by PETITE IVY PRESS
NEW YORK, NEW YORK, U.S.A.

Library of Congress Control Number: 2020943736
MOORE, CHARLES, Author
THE BLACK MARKET
CHARLES MOORE

ISBN: 978-1-7351708-0-0 (Hardcover)
ISBN: 978-1-7351708-1-7 (Paperback)
ISBN: 978-1-7351708-2-4 (E-Book)

ART / American / African American
ART / Collections, Catalogs, Exhibitions / General

Cover Illustration & Design by Keviette Minor
Foreword by Alexandra M. Thomas

QUANTITY PURCHASES: Schools, companies, professional groups, clubs, and other organizations may qualify for special terms when ordering quantities of this title. For information, email info@petiteivypress.com.

Table of Contents

Foreword

Alexandra M. Thomas

To the mainstream art world, Black art is more in vogue now than ever—this 21ˢᵗ century notoriety results from decades of activism by Black curators, scholars, and artists for whom the fight for increased representation has always been a matter of fashioning a more inclusive community. For several years, I have been working as a writer, scholar, and museum professional in the modern and contemporary art world. As a young African-American woman committed to the work of studying and teaching Black art histories, I am cognizant of art world practices and rituals that appear to be pushing toward a more inclusive vision while established ways of gatekeeping in the form of classism, racism, and other systems of oppression remain. This is the socio-cultural context in which The Black Market is published—a growing community of Black people dedicated to a more democratic vision of the art world. The spirit of this call to action led me to Charles Moore. I met Moore during my time in coursework as a Ph.D. student in African American Studies and History of Art at Yale University in New Haven, Connecticut. It was, in fact, during some of those visits to New Haven that Moore interviewed and forged meaningful connections for the ultimate production of this

book. Inspired by his steadfast commitment to supporting and uplifting Black artists, our friendship has blossomed in the 21ˢᵗ century milieu of the Black arts world. One is immediately struck by Moore's dedication to accessibility and community—traits that are not always celebrated in an increasingly elite commercial art world. In his role as a collector, writer, and scholar in the field of modern and contemporary African-American art, Moore demonstrates the generosity and intellectual rigor demanded of someone who handles African-American art and the narratives of Black artists with care. And what a deeply useful treat this book is—Moore welcomes us into his life-world, modelling his labor of love for Black artists and Black people who are interested in collecting their works of art and material culture. The book functions as an essential introduction to literary, visual, and material culture collecting practices that centers African-American artists born in the twentieth century. This is a welcome addition to the literature on Black art and culture—Moore pragmatically guides us through the terminology, philosophies, and histories of African-American artists and the people and institutions that collect their artwork. The organizational composition of the book will likely strike readers; one Black artist is explored for each decade from 1900 to 1990. Moore begins with Norman Lewis and concludes with Tschabalala Self, introducing a diverse range of Black artists working with disparate mediums in between these two examples. The Black Market simultaneously functions as an accessible introduction to art collecting, a history of modern and contemporary Black art through major artists from different generations, and an example of art historical analysis rooted in the experiences and philosophies of the artists themselves. Moore reminds us through his research practice that oral histories and close reading of artworks are as important as collecting the material artworks themselves. If we are to take heed of Moore's invitation into collecting, archiving, and learning about Black art—it begins with a meticulous engagement with The Black Market.

Introduction

A s we navigate the highly opaque art world of the 21st century, resources for Black collectors have become more vital than ever. This book offers an introduction and some sagacity on the very concept of collecting art—that is, on the concept of collecting art created *by* Black artists. I have extensive experience in this realm. Back in 2012, I bought my first piece of artwork: a signed and numbered edition print by the renowned street artist Shepard Fairey, who at the time was showing his work at the Institute of Contemporary Art Boston (ICA). On that same trip, I made a point of visiting the Harvard University campus—not knowing then that I would later enroll in its Museum Studies program, deepening my knowledge of art and collecting.

For as long as I can remember, I have always loved art museums. As a child, I grew up going to the Detroit Institute of Art, and my mother was the first art collector I knew. At Harvard, I wrote my Master's thesis—entitled *From Exclusion to Inclusion: Connecting Black Students to Art Museums*—on the disparities of access to art museums for Black students, with emphasis on how early exposure to museums affects academic achievement. "Art museums are important because they make culture available to everyone and they preserve historical artifacts," I wrote. "They are also powerful educational tools. Unfortunately, museums in

America have a lengthy history of barring entry to minorities, especially African Americans."[1] I argued that, as a microcosm, art museums represented a member-only group of elite institutions that lived by their caste systems. Many Black students, by virtue of their environment, struggled to find their way inside those seemingly impenetrable doors.

Of course, the times have since changed, at least to an extent. Now, Black artists and other communities within the art space are becoming pillars of this vital industry. Take the ICA, for instance. The museum, in its current iteration, opened in 2006. It is in the South Boston Seaport area, and when I visited the space for the first time, I had just seen the documentary *Exit Through the Gift Shop*, which profiled Shepard Fairey, the British artist Banksy, and a soon-to-be-famous artist Mr. Brainwash. When visiting art museums, my typical routine was to do just that: to enter through the gift shop, begin on the top floor, and then work my way down throughout the space before exiting back through the gift shop. I had this process down. But I didn't know how this experience at the ICA was to change my life.

It's worth noting here that Shepard Fairey is about as contentious as an artist as they come. The Rhode Island School of Design graduate gained prominence in 2008 after his Barack Obama presidential campaign poster became the subject of an Associated Press lawsuit. (Fairey seemed to have based his work on an AP photo captured by Mannie Garcia, who contended *he* retained the copyright to the photograph.) The print I ended up buying wasn't Fairey's best work, but I loved it. I was drawn in by accessibility in price (again; we turn to the theme of accessibility or lack thereof); the print cost me only $50.

In recent years, the art world has become a lucrative and commercialized market, even for Black artists. Journals are publishing clickbait, eye-catching headlines like "Sean P. Diddy Combs revealed as the buyer of the $21 million Kerry James

Marshall painting" and "Alicia Keys, Swizz Beatz Snap Up Work from In-Demand Artist [Tschabalala Self]."

Again, my purpose in writing this book. Within the following pages, I will profile ten Black artists born in the last one hundred years: Kerry James Marshall, Tschabalala Self, and Renee Cox, among others. These artists have built singular styles, offered an intimate take on the Black experience in their work, and made waves as they've explored concepts ranging from politics and gender roles to identity. Perhaps these creators rely on their unique insights to visually inform the public of their experiences that, individually and collectively, are subjective and pervasive in equal measure. They are the culture.

Often collectors are told to buy what they love. I think this is true. With one caveat, art has been commoditized and collectors should also know about this. Gordon Gekko, portrayed by Michael Douglas in the film *Wall Street*, claimed that "information was the most valuable commodity he could think of." The art world does not differ from the stock market, as here too information is, so to speak, the hottest commodity around. This book isn't meant to be a history lesson. I didn't write this to shed light on how things *should* have been, but to showcase the artists and collectors who for so long flew under the radar, and who can now bask in the recognition one might claim they deserve. I hope it inspires a new generation of Black collectors.

Above all else, in this book I intend to interpolate a few economical—and sometimes complementary—methods on which we can educate ourselves in the art world. Specifically, I hope to emphasize several methods and resources for educating oneself on art and the art market in general. Through the artist profiles and contextual details that follow, I hope to provide key insights into how things have been, how things are now, and how the art world will continue to progress if we go by current trends.

There are several other books interested readers might turn to, including *Ways of Seeing* by John Berger and *Ways of Looking* by Ossian Ward. These works offer a unique take on traversing the art world—on seeing the potential of the movers and shakers who may well still be finding their place in this ever-changing space. Then, of course, there are those books that feature the country's most renowned contemporary Black artists: *Henry Taylor* by Charles Gaines; and *Dandy Lion: The Black Dandy and Street Style* by Shantrelle P. Lewis. These works, all of them written about Black contemporary creators, challenge norms not only in the art space but in the Black American experience. Lenses range from the personal to the commercial—and these are just some books readers, viewers, and collectors might turn to for further insights into Black artistry.

Kerry James Marshall's *Mastry* is another example. The work reflects on the artist's traveling exhibition of the same name; in the late 2010s, Marshall's works were shown in some of the nation's most prominent museums, spanning coasts from the Metropolitan Museum of Art in New York to the Museum of Contemporary Art Los Angeles (MoCA). If Marshall and his contemporaries are any indication, museums, galleries, and auctions are embracing the resounding impact of Black art—revealing that contemporary players are here to stay. From Sotheby's to The Broad Museum, auctioneers and gallerists are coaxing eight-figure sums out of collectors who want in on the Black contemporary artists who have challenged traditional painting, multimedia, and photography ideals.

Put simply, there's a curatorial shift taking place. Cities like Los Angeles, Detroit, New York City, Atlanta, and Houston—home to a high number of Black people—are welcoming the Black artists and gallerists who exist in these locales. With open arms, these cities are putting on exhibitions rooted in the Black American identity. In 2018, for instance, the Seattle Art Museum showed *Figuring History: Robert Colescott, Kerry James*

Marshall, Mickalene Thomas depicting three generations of contemporary artists of color and emphasizing these creators' multidimensional perspectives on race, gender, and being Black in the United States. (That same year, the Seattle Art Museum also displayed the Jean-Michel Basquiat painting "Untitled" (1982), which sold at Sotheby's for a resounding $110.5 million—a record auction high for any American artist.)

The Studio Museum in Harlem, the Detroit Institute of Arts Museum, The Bass in Florida—over the years, I've seen these venues become a haven for Black artists. Black gallerists like Karen Jenkins-Johnson, Mariane Ibrahim and Jumaane N'Namdi, have become more commonplace than ever, paving the way for developing Black artists to develop their careers from the earliest stages. Exhibitions like *Soul of a Nation: Art in the Age of Black Power,* held at the Brooklyn Museum in 2018-2019, shed light on Black artistry between 1963 and 1983, a period during which artists of color joined forces in communities, collectives, and individually to create abstract pieces in response to the sociopolitical revolution taking place. Meanwhile, Posing Modernity: The Black Model from Manet and Matisse to Today—held first at Columbia University's Wallach Art Gallery in 2018—investigated the multifaceted nature of how Black female figures were depicted in art, ranging from emerging players to famous creators like Mickalene Thomas.

Speaking of emerging artists, collectors ought to take note: collecting from students is vital. Bachelor of Fine Arts (BFA) and Master of Fine Art (MFA) programs in some of the nation's finest institutions—Yale, Columbia, Hunter, and Columbia universities; the Pratt Institute; the Rhode Island School of Design; and the California Institute of the Arts; among others—are home to some of the finest up-and-coming artists in the country, and these institutions' thesis shows are fantastic venues for collectors to hone in on unknown talent and help to shape the future of the Black artistic landscape.

Advisors can help collectors, no matter how early in the artist's career, purchase works that are sold by the artist in question. These works could be those that will stand the test of time. Nevertheless, what is important is to garner support for young artists, early in their career, so they have the resources to continue working. San Francisco-based philanthropist Pamela Joyner, lauded as an "activist collector" by *Art Review*, has made a career of championing Black abstractionist talent. The Dean Collection, headed by Swizz Beatz and Alicia Keys, supports living contemporary Black artists in a similar fashion. The platform represents a guiding force for artists from all backgrounds, and of all artistic practices, helping both established players and those who are still in development forge a path in the industry. A large part of this book is based on discussions I had with art collectors. Collectors like the acclaimed actor Hill Harper and former NFL linebacker Keith Rivers have turned to collecting as their way of supporting works by artists they cherish. Rivers has filled his Beverly Hills home with unique and striking pieces by, among others, Sonia Gomes, Rashid Johnson, Kerry James Marshall, Arjan Martins, and Kara Walker. While art always surrounded Harper's life, he discusses why collecting art is culturally important.

Like the collectors mentioned above, I too am awestruck by the depth of contemporary Black creators' artistry. The source of my fascination with art can be traced back to when I was in middle school. My mother started collecting art by African Americans around this time. Over the years, my lessons came from reading books, and visiting museums all over the world. I lived in Italy for two years (2009-2011), have returned to Europe almost every year since, and always make a point of stopping by the various art museums in every city I visit. After purchasing that first work by Shepard Fairey in 2012, I went on a buying spree. I was introduced to an art advisor by a mutual friend, and I began setting more specific goals as I added to my collection. In 2017, I started buying work from students after seeing a MFA thesis show. In

the years since, I've worked with art advisors, collected directly from artists, been a winning bidder at auctions, purchased works from galleries, and even sourced recent pieces online. In 2019, I completed my Master's degree at Harvard and recently began a Doctorate in Art Education at Columbia University.

And so began my journey profiling and celebrating Black artists born in each decade of the 20th century—from Norman Lewis (b. 1909) to Tschabalala Self (b. 1990), with eight others in between. I interviewed collectors, art advisors, gallerists and artists, as time and circumstances allowed; some were held in person, while others I did over the phone. A few I completed via email, corresponding with the artists I so admired. Many of them are still donating and loaning their work today, I learned, doing what they can to support others in the wake of their success. These artists are excited about the future, appreciative of their respective pasts, and fully engaged in the present—particularly in what it means to be a commercially lauded Black artist nowadays.

With that, I hope the contents of this book resonate with you. I hope the ten Black artists I've profiled impact your life the same way they've affected mine. As we make our way through the 21st century, we must learn to navigate the growing art world—a space where Black creators and collectors have gained momentum, cemented their voices, and established themselves as central players in a previously white-dominated industry. BFA and MFA programs at some of the world's finest schools, internationally celebrated collectors, and lauded art museums have taken these central figures under their wing, if you will, and put the Black experience at the forefront of the art space. I, personally, am eager to see what the next hundred years will bring. Furthermore, I hope at least one of the art collectors I profiled has a story that resonates with yours and inspires you to become an art collector or continue collecting art.

Chapter 1

Collect Books before Art

Why You Need an Expansive African-American Art Book Collection
Insights, Must-Read Titles, and More

Before you build your art collection, you need to develop your book collection.

Yes, books are expensive. They are much less costly, however than buying the wrong art. After all, even the most seasoned collectors have to do their homework—and in the early stages of the collecting process, books can offer an ideal combination of visual insights, cultural analysis, and background information on any artist.

So, to make the book-collecting process as seamless as possible, I have categorized some crucial titles for your review. With these in your arsenal, you'll have a better understanding of contemporary art—more specifically, contemporary African-American art—in no time. I invite you to start with the works that appeal most to you before moving through the full list below.

Methods on How to Look and See

The following two titles offer insightful strategies on how to view and understand art.

Ways of Seeing by John Berger

Dubbed one of the most influential art books around, *Ways of Seeing* is based on a BBC television series of the same name (beloved by critics and viewers alike). The work explores how viewers look at and understand paintings, offering strategies to explore the arts in new and innovative ways. Published in 1972, it remains a staple of the modern art world.

Ways of Looking by Ossian Ward

Published in 2014, Ward's title examines how to best experience *contemporary art*. The book offers a straightforward six-step guide to understanding the latest movers and shakers and their multimedia creations. There's a marked emphasis on evaluating each piece with a critical eye but also with an open mind. Readers will carry the content of this book with them as they move forward in their efforts to evaluate art. It is a great follow-up book to Berger's *Ways of Seeing*.

ARTIST MONOGRAPHS

An artist's monograph sheds light on an individual artist's life and work. Here are some definitive titles for your reading pleasure.

Kerry James Marshall: Mastry by Ian Alteveer, Helen Molesworth, et al.

This book features over 100 works of the prolific painter Kerry James Marshall. Accompanying his traveling retrospective, it includes essays by renowned critics alongside the artist's own words and imagery. This monograph showcases vivid and abstract art arranged thoughtfully by subject.

Carrie Mae Weems: Three Decades of Photography and Video by Kathryn Delmez

Look no further for a powerful blend of daily life and social commentary. From the late 1970s, Carrie Mae Weems' photographs, films, and installations have offered an authentic view of social justice themes and the African-American experience at large. Readers will enjoy the essays in this collection, paired with 200 of Weems's most relevant pieces.

Consuming Stories: Kara Walker and the Imagining of American Race by Rebecca Peabody

Peabody's work takes a storytelling approach and investigates the work of contemporary American artist Kara Walker, exploring production pieces from wall-sized installations to retooled photocopies to custom theater curtains. This monograph examines narratives of race, power, and desire, following Walker throughout her still-unfolding career.

Henry Taylor by Charles Gaines

For three decades, the renowned Henry Taylor has documented impactful scenes of New York, Los Angeles, Africa, and Europe, documenting his figures with authenticity, vibrant colors, and abstractions. Readers will linger on this definitive monograph featuring over 200 of Taylor's paintings, each one accompanied by a handwritten description.

EXHIBITION CATALOGS

Readers can add a hint of memorabilia to their book collection by reading the exhibition catalogs of the following contemporary artists.

Howardena Pindell's "Autobiography"—Garth Greenan Gallery, New York (2019)

This catalog offers deep insights into iconic artist Howardena Pindell's life and career. In 1979, a car accident left the artist with acute memory loss—a symbol of the destruction and reconstruction she later explored in her multimedia work. Readers can expect cut and sewn strips, swirling patterns, and complex surfaces from this exhibition catalog.

Titus Kaphar's "UnSeen: Our Past in a New Light"—Smithsonian Museum, National Portrait Gallery (2019-2020)

Titus Kaphar, in this exhibition catalog, examines the misrepresentation of underserved communities in both portraitures and American history. The artist delves into the sacrifices people of color made from as early as our nation's founding, defacing and peeling back the figures in his paintings to reveal how historical leaders hid their systemic prejudices.

Nate Lewis's "Latent Tapestries"—Fridman Gallery (2020)

"Latent Tapestries" blends elements of sculpture, photography, ink, and graphite drawings, revealing how the artist's critical-care nursing experience challenged perspectives on race. With an emphasis on paper, Nate Lewis builds patterns and textures so they resemble cellular tissue. It's an anatomical approach that will teach viewers to experiment with the way they experience modern art.

These works offer a specialized, vivid take on themes relating to the contemporary African-American experience.

Dandy Lion: The Black Dandy and Street Style by Shantrelle P. Lewis

Vibrant suits, elaborate bow ties, and colorful accessories embody the style of the modern "dandy." Shantrelle P. Lewis defines this figure as a "high-styled rebel," and reveals in her work how these individuals have helped transform not only the fashion industry, but the significance of what it means to be Black, stylish, and masculine. This curated collection showcases the dandy subculture with intimate photographs and electrifying patterns.

Samella Lewis and the African American Experience by Samella Lewis

In this work, Dr. Samella Lewis—an author, critic, professor, historian, and multimedia artist in her own right—explores the lives of the individuals who focus on African-American art. An influential voice in the Los Angeles and national art communities, she offers a unique perspective on what it means to make and collect art.

I Too Sing America: The Harlem Renaissance at 100 by Wil Haygood

Wil Haygood's project is a love letter, of sorts, to the Harlem Renaissance. The author illuminates the people, art, literature, music, and social history of the era by focusing on paintings, prints, photographs, sculptures, and written ephemera. Romare Bearden, Allan Rohan Crite, Palmer Hayden, Jacob Lawrence, and James Van Der Zee are just some of the featured Black visual artists.

Consider the following titles to further your understanding of American art and contemporary art collecting.

The American Century: Art & Culture, 1900-1950 by Barbara Haskell

The subject of a year-long Whitney Museum exhibition, this book offers a display of the most celebrated American art from the first half of the 20th century. Depicting works from both famous and lesser-known artists, the volume covers the cultural shift that took place and informed the arts during this time. Barbara Haskell's book is rich, detailed, and set in sociopolitical times. Readers will value the 750 full-color and duo-tone illustrations included in the text.

The American Century: Art & Culture, 1950-2000 by Lisa Phillips

A continuation of the previous title, Lisa Phillips's work sheds light on American artists from the time shortly after the Second World War through the end of the 20th century. From Jackson Pollock to Willem de Kooning and other artists, this book emphasizes style, performance, and inventiveness in post-war America. This volume too includes 750 full-color and duotone illustrations.

The Lives of Artists: Collected Profiles Hardcover by Calvin Tomkins

This collection of artist profiles, written by prolific journalist Calvin Tomkins, highlights the best in modern art from the 1960s to today. The six-volume work is a compilation of the author's most celebrated artist profiles of everyone from Cindy

Sherman to Mark Bradford. The book lies at the intersection of art history and human interest, showcasing artists' creations in contrast to the ever-evolving world in which they live.

Collecting African American Art: Works on Paper and Canvas by Halima Taha

Art enthusiasts—in particular those who focus on contemporary African-American art—will devour this page-turner. In this book, Halima Taha works tirelessly to dispel the myth that collecting art is solely for the wealthy. To give beginning collectors the resources they need to thrive, the book includes nearly 200 works, showcases a range of artists, and offers practical advice on working with dealers. Think of this guide as your one-way ticket to becoming an informed collector.

BONUS

Invisible Man by Ralph Ellison

While I was writing this book, Ellison's work became a reappearing leitmotif by artists I was researching and collectors I interviewed. The book discusses the cultural and intellectual issues encountered by many Black people in America and around the globe. The famous last sentence, "Who knows but that, on the lower frequencies, I speak for you?" explains the hostility faced by the protagonist.

Race Matters by Cornel West

Dr. Cornel West, is a leading civil rights figure, and genius on subjects that include moral authority and cultural inclusion. This book negotiates the racial biases and inequities in America felt by those with darker skin tones. I placed it in the bonus

section, but this really should be essential reading by anyone who wants to understand the design of systemic racism.

Stony the Road: Reconstruction, White Supremacy, and the Rise of Jim Crow by Henry Louis Gates Jr.

The subject is bold. Some people think the civil rights era ended with Blacks and whites being equal in America. Dr. Gates notes, it was possible for many to detest slavery, yet at the same time to detest the enslaved and the formerly enslaved with equal passion. Sure, America allowed a Black president, while immediately afterwards it elected a blatantly unapologetically racist one.

Album Cover: *Graduation* by Kanye West

Kanye has collaborated with artists ever since he started producing and rapping. From his collaboration with Virgil Abloh and KAWS on his album 808's to My Beautiful Dark Twisted Fantasy's George Condo cover, he continues to commission artists to bring his ideas to life. As an album cover, I invite readers to explore the works of Takashi Murakami and his mark on contemporary art.

A WORD ON THESE ART BOOKS

These are just some titles you'll want to add to your book collection as you further immerse yourself in the contemporary African-African art space. I invite you to sit down with these works, spend some time paging through your favorites, and take careful notes so you can start collecting art with confidence.

Ultimately, books will help to lay the foundation for your success. I hope that you can now view new pieces of art in a clear and unobstructed way, all while working to develop a meaningful and cohesive art collection.

A note about catalogs that include museum guides, old auction catalogs, art magazines: None of these are listed, but I think they are very helpful in understanding previous collecting principles by institutions, private collectors, and what are in the minds of print journal editors.

Chapter 2

One Black artist born every decade: 1900 to 1990

African American & African Diaspora art in this past century has possibly been some of the best art of the period. Ergo, to own this work is to collect both greatness in art and culture. Master painters like Norman Lewis, Kerry James Marshall, and Mario Moore have placed work in some of the most prestigious art institutions in America and throughout the world. Here I've taken the liberty to highlight a few of those artists. I chose one artist, born in each decade from 1900 to 1990. In some instances, I gave a brief history and chose a piece (as in the case with Norman Lewis), or described a series of works (as in the case with Jacob Lawrence's War Series). I have had the luxury of meeting some of the most influential living American artists of our time: Derrick Adams, Howardena Pindell, Mario Moore, and Tschabalala Self. Excerpts from my encounters and interviews with these artists were taken into account in highlighting them. This is not to be considered an in-depth analysis of the History of African American art, but merely my selection of those artists that influenced my reason for writing this book. It is worth mentioning that all these artists are important, not merely because of their art, but also their monetary value, social prestige, and their importance to the narrative of Black culture.

Norman Lewis b. 1909

American Totem makes you linger. The painting was discussed at length after its acquisition by the Whitney Museum in the spring of 2019. It is one of Norman Lewis' most iconic paintings. The canvas evokes contrast from every angle: Black vs. white, sharp vs. soft, eerily still yet rife with movement and suspense. It's beautiful, yes—and highly political. One of the artist's "Civil Rights" paintings, the piece depicts an abstracted totem representing a hooded member of the Ku Klux Klan. Inspect, and you'll find looser forms: a skull here, a mask there.

Norman Lewis was born in the Harlem area of New York City and grew up there at the turn of the twentieth century. As a painter, he was determined to express his view of the Black experience through his unique abstract works of art. *American Totem* is a depiction of an American tragedy. The parts of the painting—the symbolism of the hood, the vacancy of the eyes—are crucial to the whole. From an American cultural studies standpoint, there is a great deal to explore here.

Before reviewing *American Totem* in more detail, the viewer might consider Lewis's life and career trajectory. Lewis was lauded for his striking depictions of the complexity of American society. Many consider his work as being both poetic and socially conscious. Lewis masterfully communicated his vision and gave you additional commentary: the work is complex and sometimes an explanation is necessary.

This wasn't always the case. Lewis launched his career as a Social Realist, showcasing the inequality of poverty and racism in a blunt, straightforward manner. However, he soon stated that "painting an illustrative statement that merely mirrors some of the social conditions" was not an ideal agent for change, and the artist pivoted his focus accordingly.

Today he is one of the few Black painters linked to the New York School of Abstract Expressionist artists. Inspired by

the likes of Wassily Kandinsky and Mark Tobey, it was around 1946 that Lewis joined this first wave of abstract expressionist artists—a group that included Franz Kline, Willem de Kooning, Jackson Pollock, and other gestural painters. However, Lewis committed to sparking discussion around racial inequality, all while removing figures to allow the viewer to gather their ideas behind his mastery of art: abstract.

Lewis wanted his art to speak for itself. "I wanted to be above criticism so that my work didn't have to be discussed in terms of the fact that I'm Black," he once revealed. You might say that Lewis achieved this goal with *American Totem*. He completed the oil painting while transitioning from bright calligraphic forms to his "Civil Rights" series—a collection composed of stark Black-and-white paintings, full of negative space, that explored a calamitous period in U.S. History.

Whitney curator David Breslin claimed that *American Totem* features unprecedented reach and mass appeal. "Made at the height of the civil rights movement by an under-appreciated protagonist," this work is the anchor to the museum's selection of works 1900-1965 on exhibit in the 2020 exhibition of the Whitney's permanent collection.

In a 1976 interview, conducted for his retrospective at CUNY that year, Lewis said he painted social subjects earlier in his career because he believed it would change the way people think if they were to see what was happening to Black folks. He later turned to abstract paintings after determining even in plain sight those images made little difference in how people felt about the subject.

He is credited with forming The Spiral Collective, a group of artists and writers who focused on art as a method to address racial inequality. Besides this, Lewis took part in the Civil Rights Movement of the 1960s. Poignant, racially inflected paintings like *American Totem* (1960) make it tempting to view all of his paintings through the lens of social change.

Ultimately, while Lewis's painting style developed over the years, he maintained his focus on social justice throughout—a noteworthy feat that cemented Lewis as a movement unto himself. Norman Lewis paved the way for the likes of Ed Clark, Howardena Pindell, and other Black artists who aim to push past boundaries to create a lane using visual art as their tool.

Jacob Lawrence b. 1917

The War Series by Jacob Lawrence was painted on the heels of World War II, in 1947. African Americans were not immune to the wreckage of the world's second go at international combat. An estimated total of 700 of the nation's Black population had perished. Jacob Lawrence created a 14-part series documenting the varied emotional rollercoaster.

WAR SERIES SYNOPSIS

One of the highest compliments an artist can receive is when a peer admires or inspires their work. Derrick Adams famously applied to the Pratt Institute because Jacob Lawrence once taught there. Arguably the most famous African American artist of the 20th century, Jacob Lawrence was as prolific as they come. Throughout his life and career, the gifted artist painted hundreds of pieces, many of which have become central attractions in museums across the US.

Jacob Lawrence's works now reside in the permanent collections of several museums, including the Whitney Museum, the Museum of Modern Art, and the Metropolitan Museum and Art. Lawrence was best known for illustrating the African American experience using dark brown and Black figures against a background of contrasting vivid colors. While he was always of the opinion that one cannot "tell a story in a single painting," he conveyed profound sensations through his paintings.

Perhaps it was this ability to tell profound stories about African American circumstances in broad strokes that made him one of the foremost African American figures of his time. He often adopted historical events in carrying out his social commentary. Some of his notable collections include the Migration and War Series.

The War Series, owned by the Whitney Museum, is magnificent for the events that Lawrence described through its 14 pieces. He witnessed something scarce at the time—Black and White Americans sharing the same spaces and circumstances.

The fact that a socially conscious painter of his depth was on hand to witness and describe these events makes this collection even more important.

Early life and history

Jacob Lawrence, born in1917, was raised in New York City. Although he wasn't born in the city, his paintings would come to be deeply influenced by the shapes and colors of Harlem.

He started painting at a very young age and was encouraged to explore his talents by teachers, such as the African American artist Charles Alston. Even from an early age, Lawrence's unique style and focus on social commentary through art were already becoming evident. At just 21 years, his series of paintings on the Haitian general, Toussaint L'Ouverture, was exhibited at the Baltimore Museum of Art. This was followed by other intriguing pieces on the lives of Harriet Tubman, Frederick Douglass and John Brown, all iconic figures of abolitionist and resistance movements.

His Migration Series comprised 30 paintings on the migration of African Americans from the American South to the North, cemented his narrative painting skill and fully announced his vision to the country. Considering this backdrop, one can better appreciate the context and prism through which he saw and recorded the events of World War II through his War Series.

At the outbreak of the Second World War, Lawrence was drafted into the US Coast Guard, where he served as a public affairs specialist. In his first year, he served in St. Augustine, Florida, in a racially segregated regiment. African Americans were not immune to the wreckage of the world's second go at international combat. As previously noted, an estimated total of 700 of the nation's Black population perished.

However, he later served in a racially integrated regiment as Coast Guard artist. In this manner, he came to witness another set of unprecedented events through his service on the first naval boat with a racially integrated crew.

He painted the War Series on a Guggenheim Fellowship after discharge from the military in 1946. With 14 pieces in the series, each constitutes a page in the progressive narrative that was his military service.

Although the majority opinion is that Lawrence painted this series as an autobiography of sorts, straight documentation of his wartime experiences, some critics differ. They view the paintings as part of the artist's sustained social commentary on racial topics and the integration he witnessed during service.

Both opinions are valid, as it is arguable that the paintings combined autobiography and social commentary. Lawrence had already displayed enough of a penchant for tackling deep issues in his paintings. It was unlikely he would be unaware of the social significance of the war and the racial integration it forced between Black and white troops.

The 14 pieces in the series record the realities of the war and the bundle of emotions that accompanied it under the hand of a man that "tried to paint things as I see them." True to form, the images are entirely forthright, devoid of overstatement or elaboration.

They progress from the first panel, *Shipping out*, and continue until the last, *Victory*. When asked which of the pieces was his favorite, Lawrence predictably chose *Prayer*.

The piece portrays a single figure kneeling within the bulkhead of a ship with his head bowed in prayer. The deep browns of the figure contrast with the deep blues of the ship's interior to create a sense of vastness, a vastness not just of the vessel but also of the sea. It captures the ultimate futility that man senses on the edge of his endeavors and the instinct to find meaning in a higher power at times of great conflict. The panel also represents a paradox that stands starkly against the war theme of the paintings.

The panel is just one in the rollercoaster of emotions depicted by the pieces in the series. The paintings carry through the daunting prospects of *Shipping Out,* to the terrible resignation of receiving a dreaded *Letter* and the sweet relief of a night out *On Leave.* While running through the narrative, it is a subtle reminder of the apparent integration in fortunes and circumstances that both Blacks and whites had during the years of the war.

The final panel, *Victory,* portrays a kneeling man whose pose shows everything but victory. The subdued tone of the panel and colors show the "pyrrhic" feel of the moment with the soldier seeming to have lost more than he gained in a war that was not his own.

The figure's hands tell a story all on their own. The left hand is a lighter shade than the right, and both are gripping a rifle in between. This shows a nod to the combined efforts of an army integrated solely for expediency and which eventually found brotherhood through violence.

The complete list of pieces in the 14-panel War Series collection is:

❖ *Prayer*
❖ *Another Patrol*
❖ *Shipping Out*
❖ *Alert*
❖ *The Letter*

- ❖ *Docking – Cigarette, Joe?*
- ❖ *On Leave*
- ❖ *Beachhead*
- ❖ *Purple Hearts*
- ❖ *How Long?*
- ❖ *Casualty - The Secretary of War Regrets*
- ❖ *Reported Missing*
- ❖ *Going Home*
- ❖ *Victory*

Ed Clark b. 1926

I never got the chance to meet Ed Clark; he passed away in 2019. But by the time I heard about the legend, he had already put a halt on traveling outside of Detroit and his work had reached levels beyond my access.

Ed Clark may have grown up in New Orleans, but he carved his teeth in the Midwest after studying at the Art Institute of Chicago. His first show was in 1955 at a YMCA in Chicago. While he's known for his use of the broom to create dynamism on the canvas, they also credited him as one of the first—if not the first—artist to paint on a shaped canvas.

For most of his lengthy career, very few collectors were buying the works of African American artists and white-dominated art institutions didn't provide opportunities for career advancing criticism. The art world in Paris, however, didn't care what color you were, and for Clark, as for many African American artists in the immediate aftermath of World War II, it offered space to explore. He lived there in the 1950s, and travelled frequently since, harvesting influences in terms of tonal combinations and composition that he adds into the mix of his art.

Historically, a lot of his support came from the African American art community by default. Alaina Simone, a multi-faceted

African American art world professional, remembers first seeing Clark's work in Detroit in the late 1990s, introduced by the legendary Motor City gallerist George N'Namdi. "Meeting Ed was great," Simone told *Artnet News*. "He had travelled the world and he used a push broom to paint the work—which was like a comment on his ability to think outside the lines."

Private gallerist Alitash Kebede is another longtime Clark fan. She has had a career spanning over three decades focused on collecting and exhibiting Black artists and remembers learning of Clark while visiting Peg Alston. Kebebe's space, Alitash Kebede Fine Arts in Los Angeles, first showed an Ed Clark painting—way back in 1988. "After a while, the truth comes out," Kebede told me, "a painter as good as Ed Clark eventually must be appreciated and respected."

Despite his lengthy list of achievements, for many longtime Clark fans it was still exciting to see him get his due in a way rarely achieved by living artists of color of his generation. The mainstream success that Clark finally enjoyed before his death may make it an even more important note of the networks that have nurtured the conditions, over long years, for his new level of new renown. Others who have championed him over the past four decades include Peg Alston Fine Arts, a historically important New York private dealer who focused on advocating for Black artists, and the artist David Hammons, who is said to have one of the largest collections of Clark works and been an advocate of his behind the scenes.

Clark wasn't always considered blue chip. Back in 2007, you could have easily picked up a mid-1980s push broom painting from a Swann Gallery auction for less than $25,000. Even at that price, it went unsold. Yet by May 2019 at a Phillips auction, the momentum had definitely shifted: a 2007 work that had been estimated to sell between $80,000–120,000 came in at $337,500 once the hammer came down.

Faith Ringgold b. 1930

Historically, African American artists have often been ostracized for their work. The Civil Rights era of the 1960s was a tumultuous time in American history. With so much violence and brutality centered on African-Americans during this period, Black artists such as Faith Ringgold created masterpieces that spoke to the struggle of the Black person in America. Few pieces of art are as telling and as sobering as Faith Ringgold's "American People Series #20: Die," acquired by New York's Museum of Modern Art in 2016.

In what was the 20th piece in her American People series, hundreds of people showed up to support Faith Ringgold when she unveiled her masterpiece at her gallery opening in 1968. While the excitement for Ringgold's next piece in her already celebrated series was palpable, not everyone would be ready for what Ringgold was about to present to the world. It is said that a woman, upon emerging from the elevator into the 57th Street gallery in New York, saw the painting and screeched. According to Ringgold, the woman then stepped back into the elevator and exited. Ringgold's newest piece of Black art didn't go down easily with all who would view it.

According to Ringgold, the painting, which combines two panels and extends to 6-feet-by-12, inspired by Jacob Lawrence's mid-century reinvention of history painting, and by Picasso's antiwar masterpiece "Guernica." Aside from this inspiration, Ringgold also attests that she felt moved to create her masterpiece in response to the race riots that were breaking out across America in 1967, most prominently in Newark and Detroit. Between the years 1965 and 1968, there were 150 riots in the country. In the year 1967 alone, the year in which Ringgold painted her masterpiece, 1,800 people injured, and 83 people killed in these riots alone.

She wanted her masterpiece to show people that the riots were not just "poor people breaking into stores" but that they

were, rather, about "people trying to maintain their position, and people trying to get away." Ringgold said that "everybody was involved" and pointed out that this was the reason that half of the figures in her painting were white while the others were Black, and the reason that she chose to depict the figures in cocktail dresses and suits.

Ringgold's "American People Series #20: Die" is a powerful piece of Black art that rings true to the chaos and violence experienced during the Civil Rights era. With a maelstrom of violence depicted on the canvas, it is hard not to notice Ringgold's inclusion of two small children huddled together on the ground, one Black and one white. This seems to speak to how so many felt. So many people felt vulnerable and lost in the violence. This is truly one of the most powerful things that Ringgold's "American People Series #20: Die" has to say about the time in which it was painted.

Faith Ringgold was born in New York City in 1930. She was raised during the period of the Harlem Renaissance and grew up with exposure to rich African-American culture and art. From early on, Ringgold developed an interest in art. After receiving her Bachelors in Fine Art and Education in 1955, Ringgold began teaching art at a public school. She would finish a Masters at City College.

While working as an art teacher, she first began painting her popular series "American People." Each of the paintings included in Ringgold's American People series portrayed the Civil Rights movement from a uniquely female perspective. Ringgold's first solo show was in 1967, when the controversial piece was unveiled.

In what is perhaps some of her most well-known work, Ringgold began a series of quilts to tell her own story after attempting, unsuccessfully, to have her autobiography published. The first quilt, *Echoes of Harlem*, would be assembled in 1980 followed by her narrative quilts *Who's Afraid of Aunt*

Jemima in 1983, a tribute to Michael Jackson *Who's Bad* in 1988, and *Tar Beach (Part 1 from the Woman on the Bridge series)* that same year.

Eventually, Ringgold became a professor of art at the University of California at San Diego, where she would teach until 2002. In recognition of both her art and work as a civil rights activist, Ringgold has been awarded numerous honors, including a Guggenheim Fellowship for painting, a National Endowment for the Arts Award, and an NAACP Image Award. Her paintings continue to be exhibited in major museums around the world with "American People Series #20," her masterpiece, now hanging alongside Picasso's "Les Demoiselles d'Avignon," one of the Museum of Modern Art's most valuable paintings.

Howardena Pindell b. 1943

HOWARDENA PINDELL — A LILY IN HER PRIME

Art collecting should never be merely rote or commercial. It is an emotional endeavor that is driven more by values, sentiment and personality than it is by mere financial projections. Truth be told, if collecting was treated as merely another line on a spreadsheet, thousands of cornerstone pieces by some of the most recognized artists never would have sold. Worse, those who owned these prestigious pieces never would have enjoyed the opportunity to add such impressive works to their collection.

Howardena Pindell epitomizes this premise perhaps more than anyone else. With a unique artistic style and background more peculiar than most, Howardena definitely is no run-of-the-mill artist. Her unique art did not really find much of a market in the heydays of the '80s and '90s. For collectors who thought mostly in financial terms, Howardena would have been an 'iffy' bet, as there were no indications of huge commercial value in her works. But 30 years on and Howardena's works

have come into their own, blooming like an oriental lily in the golden light of August.

Today, she is one of the most popular artists in the United States. Although she has always produced stunning pieces over the course of her career, she did not reach critical acclaim until much later. Now, Howardena's works have headlined dozens of solo and group exhibitions in some of the most prestigious museums within and outside the U.S., including the Rose Art Museum, the Museum of Modern Art, and the Whitney Museum of American Art.

EARLY LIFE AND CAREER

Howardena Pindell was born in Philadelphia, Pennsylvania in 1943 to Howard and Mildred Douglas. She demonstrated a gift for art from a young age, and recognizing this gift, her supportive parents registered her in art classes to help tease out her talent. She eventually displayed her promise in figurative art at the Fleisher Art Memorial, Philadelphia College of Art and the Tyler School of Art. Howardena completed her BFA at Boston University and received her MFA from Yale University in 1967.

Unlike many of her peers on the African American art scene, Howardena did not immediately reach her artistic prowess; instead she rarely churned out pieces. She took up a position with the Department of Prints and illustrated books at the Museum of Modern Art in 1967, working in a range of capacities, including Exhibition Assistant, Assistant Curator, and Associate Curator. But like many of her peers, her art slowly came to be defined by the passive (and often active) racist and sexist undertones of her environment.

For instance, she could not immediately secure a job after graduation. When she thought she had been offered a job, she arrived at the appointment only to find out they had thought she was a man. They thought her name was a typo and was actually spelled Howard, so when she turned out to be a female,

their answer was a curt "we're not interested." She says, "They didn't want to hire a woman. I think they were shocked that I was Black, but then the woman thing added to it. They wouldn't even sit down and talk to me."

Encounters like this played a role in shaping the politically charged art that Howardena would create. She relates an event from her childhood when she and her father were traveling through northern Kentucky. Her father liked root beer, so they stopped to buy some. She noticed that the mugs had red circles on them and when she asked her dad what this was, "he explained that it was because they were meant for people of color." That experience affected her profoundly and, according to her, would come to be the emotional basis of the circles that permeate her art.

ONE ARTIST, MANY VOICES

Howardena is a painter and mixed media artist. Her unique style draws on the use of a wide variety of techniques and sometimes esoteric materials, including paper, manila folders, a hole punch and the odd atomizer. She often uses interesting processes of destruction and reconstruction to create masterpieces bursting with color and underlined by her "pointillist" circles. The media through which Howardena expresses her art—including paintings, collages, "video drawings" and "process art"—have also helped the critical acclaim that now greets her artwork. Although she trained as a figurative painter, her works have been far more abstract than figurative, and this has earned her ire from some of her acquaintances back in Boston because of it.

She is outspoken and has been so from the start. Her artworks represent social issues, and characteristically she pulls no punches when tackling them through her art. For a while, her art also served as an autobiographical trail after she was involved in an accident in 1979. That was the same year in which

she started to teach art at Stony Brook University, where she has been teaching ever since. The accident caused her severe memory loss and her art, she says, became a source of healing. Her painting, *Autobiography*, is especially reminiscent of this. In the painting, she cut out and sewed a sketched outline of herself on a piece of canvas as part of a large and complex collage. She then cut up postcards she had received from friends and collected on her own travels, painting in between strips attached to the collage, and creating a poignant piece containing the breadcrumbs of her lost memory.

A LILY IN HER PRIME

Collectors and critics like an artist with a personality and Howardena's is stronger than most. Her personality gives a lot of extra context to her work and is part of why she is well-sought after today. She is the recipient of numerous awards, most of which have come much later in her life and career. She received a Guggenheim Fellowship in 1987, the College Art Award for Lifetime Achievement in 1990, Award for the Best Art Book in 2018, Artists Legacy Award, and a US Artists Fellowship in 2020.

These awards are part of a renaissance that Howardena's work has been enjoying in recent times. Since the start of her recent resurgence, her works have enjoyed multiple exhibitions in institutions and at events throughout the US, to much critical acclaim. To this day, she continues to create her unique brand of art, churning out very few pieces a year, interspersed with one or two big ticket paintings.

Kerry James Marshall b. 1955

When Kerry James Marshall's 1997 painting *Past Times* sold for $21.1 million at Sotheby's in 2018, it was a milestone for Black artists. Never had a painting by a living Black artist sold for so much money, and yet it was only the latest in a string of

milestones that Marshall had set throughout his career. Back in 2016, Chicago's Museum of Contemporary Art had hosted an exhibition of his work, entitled *Mastry,* from April 23 to September 25 of that year. Referring to Marshall as "one of America's greatest living artists," the MCA presented works that showcased his development as an artist through four decades.

Born in 1955, Marshall spent his earliest years in Birmingham, Alabama. Eight years before the marches from Selma to Montgomery would surely shape him deeply. In "Souvenir II," one of a series of four paintings, Marshall depicts a group of angels that includes Viola Liuzzo, a housewife whom the Ku Klux Klan murdered while she was returning to her home in Detroit after taking part in the marches. The painting, which is part of the permanent collection at Addison Gallery of American Art in Boston, was at the center of a special exhibition at the Detroit Institute of Arts in late 2019.

Marshall grew up in a working-class home, raised by a father who was a kitchen worker and a mother who was a homemaker. As a pastime, his father would purchase machines and items at pawn shops, taking them apart and then figuring out how to put them back together. While doing this, he encouraged Marshall to think analytically and creatively, teaching him to visualize the machines and understand how the unique pieces all worked together. Throughout Marshall's work, this high level of constructive and reconstructive intelligence is apparent, various pieces and characters combining into a scene to form images that, although their parts are still distinct, form single, coherent messages.

Moving to Los Angeles while he was still young, Marshall lived close to the Black Panther's headquarters. In his own words, "You can't be born in Birmingham, Alabama, in 1955 and grow up in South Central [Los Angeles] near the Black Panthers headquarters and not feel like you've got some kind of social responsibility. You can't move to Watts in 1963 and

not speak about it. That determined a lot of where my work was going to go." Throughout his work, there is a clear awareness of the social circumstances in which he developed as an artist and an unhesitating willingness to face the reality of these circumstances honestly, even bluntly.

Artist Charles White, who started mentoring Marshall while the younger artist was still in high school, took a similarly honest and unflinching approach to expressing his conscientiousness in his work, and Marshall has never minced words as to the influence his mentor had on him. Writing in *The Paris Review* in 2018, Marshall said, "I have been a stalwart advocate for the legacy of Charles White. I have said it so often, it could go without saying. I have always believed that his work should be seen wherever great pictures are collected and made available to art-loving audiences. He is a true master of pictorial art, and nobody else has drawn the Black body with more elegance and authority. No other artist has inspired my devotion to a career in image making more than he did. I saw in his example the way to greatness." Since the publication of this essay, both Sotheby's and Christie's have put up paintings of White's up for auction, fetching record-setting prices for the artist's work. It was during his studies with White that Marshall first created art using the style that has since become a hallmark of his work, portraying Black men with a very dark skin tone that is Black.

Of Marshall's MCA retrospective, critic Jason Farago of *The Guardian* pointed out its timeliness, writing, "In any other year, the recently opened retrospective of the paintings of Kerry James Marshall at New York's Met Breuer would be a significant event. Against the current backdrop of racist demagoguery and national disbelief, it arrives as a godsend." Sasha Geffen of *Chicago Reader* speaks to Marshall's defining role in contemporary American art: "Marshall's most arresting paintings show the world in all its luminous complexity, on street corners and in barbershops or living rooms, symbols of life amid

structural racism's insistence on death." Together, these lines state the power and the impact of Marshall's work, highlighting their undeniable relevance to the American zeitgeist and their equally undeniable timelessness in the loving way that they portray Black American life.

For all of his stark social commentary, Marshall's work can be deeply comforting, presenting the Black communities in which he came of age, first in Birmingham and then in Los Angeles. Empathy and compassion shine brightly through in all of his works, even those depicting harrowing subject matter, and his affinity for his subjects is clear. This is perhaps the most palpable characteristic of all the work that he has produced, its inimitable capacity both to touch the heart and kick-start the mind.

Marshall earned his Bachelor of Fine Arts at Los Angeles' Otis College of Art and Design, an institution that has since issued him an honorary doctorate. Formerly, he taught at the University of Illinois at Chicago. He and his wife, actress Cheryl Lynn Bruce, whom he met while he was an artist-in-residency at Harlem's Studio Museum, still call Chicago home today. In 1997, the MacArthur Foundation (a.k.a. "the MacArthur genius grants") named Marshall a fellow. In the citation accompanying his award, the Foundation wrote, "Conceptually experimental and artistically innovative, Marshall also builds on an enormous range of knowledge and admiration for the traditions of art history and western painting practices." I expect to see many headlines mentioning Marshall's work for years to come.

Renee Cox b. 1960

Renowned artist Renee Cox has made a career of deconstructing stereotypes. Born in Colgate, Jamaica in 1960, Renee later moved to Scarsdale, New York with her family. It was in New York where Cox initially set out to be a filmmaker—and where she instead took up photography after graduating from Syracuse University.

After a multi-continental stint as a fashion photographer in the early 1990s—around the time she gave birth to her first child—Cox began focusing on fine art photography, where she believed (and rightfully so) she would have more creative leverage. Cox received her Master of Fine Arts degree from the School of Visual Arts in New York, got admitted into the Whitney Independent Study Program, where she quickly made a name for herself in the photography space, and the rest was history.

Today Cox is arguably one of the most controversial, albeit celebrated, artists of her time. She has continually used her own body, both nude and clothed, to celebrate Black womanhood and empowerment—and to speak her thoughts on what she still believes to be, in many ways, a racist, sexist society.

Cox is no stranger to shedding light on critical social issues. In 2001, her piece *Yo Mama's Last Supper* instigated enormous controversy. A provocative work showcasing Cox's nude body as Jesus alongside a table of Black disciples (and a white Judah), the aptly named remake of Leonardo Da Vinci's *Last Supper* sought to challenge stereotypes and empower minority groups. In my opinion, Cox achieved her messaging goals and then some. She isn't afraid to push boundaries, and the impact of her art has truly been expansive.

On multiple occasions in 2019, I sat down with Renee at her studio in the Bronx and discuss her remarkable career trajectory. We talked about motherhood, the resounding influence of her *Yo Mama* series (among other artistic undertakings), and that women—in the artist's words—can "have their children and still have a viable career."

I find Cox's voice resonant—and her passion contagious. Together, we explored themes like "elevation," the reconstruction of the African-American economic system, and the importance of teaching young girls and women to take back control of their lives and bodies. We also discussed my favorite Renee Cox series entitled *The Discreet Charm of the Bougies*,

which came to fruition during a difficult time for Cox: her midlife crisis, or a period during which she felt "invisible."

The images are mesmerizing: *Snow Mountain* depicts Cox dressed in Black, standing on a trail surrounded by greenery, staring forlornly into the camera. *Black Housewife*, meanwhile, shows Cox seated on a mustard-orange sofa, resting one hand on a standard poodle while a young white woman serves her cocktails in a full maid's uniform. In the background, the viewer takes in a life-sized print of a nude Cox holding her infant son. There's a great deal to process in the images stillness.

I could go on and on—and in my conversation with Renee Cox, I do just that. I urge you to continue reading to learn more about the photographer's artistry, her view of sex and mother-hood, and the legacy she hopes to leave. Cox's artistic journey has always been an autobiographical one, every series offering commentary on a period in her life.

Yo Mama was inspired by her second pregnancy during her time in the Whitney Independent Study Program. As the first woman ever to be pregnant in this program, Cox was stunned by the response of her peers. Instead of the congratulations she had expected, she was met with a sea of questions and concerns about the trajectory of her career. Cox has always felt that having children was important but not impossible as so many of her peers seemed to think. As a pregnant Black woman, she felt it was necessary to make a statement about this; it was important to create images that could empower other women who were dealing with similar issues during pregnancy or even just thinking about pregnancy. This was the genesis of the *Yo Mama* series. The *Yo Mama* depicts a nude cox standing resolutely with her infant son in hand against a pitch-Black background. Many have described Cox as holding her son like a weapon, a comparison that completely detracts from the purpose and beauty of the piece. Violence has never been an inspiration for Cox, only female empowerment.

A piece that has kept its relevance for over 25 years, *Hotten-tot Venus* is a striking Black and white image that features Cox in exaggerated prosthetics placed over her chest and buttocks. This image was inspired by the grotesque treatment of Sarah Baartman in the 1800s—she was paraded around, exploited and sexualized for the entertainment of the same white people who ridiculed her looks yet ironically tried to emulate them with undergarments such as the bustle. After Baartman's passing, French naturalist Georges Cuvier made a cast of her body, pre-served her skeleton and pickled her brains and genitals which remained on display in a Parisian museum until 1974. Although her remains were removed from the museum they were not repatriated until 1994 when Mandela came into office. Right around this time, Hottentot became relevant and Cox told the heart-breaking story of Sarah Baartman through photography.

Even 25 years later, *Hottentot's* relevancy is still apparent—white celebrities like Kim Kardashian have adopted this body type, so now it's deemed acceptable and coveted by thousands of women getting implants and injections just to mimic this big butt. "Black women naturally shaped this way have been viewed as overweight and unattractive for years, but its glorification has transformed it," said Cox "into a body type that's likeable and desirable." Black women have been hyper-sexualized and dehumanized for centuries, yet Cox's controversial work has always pushed young girls and women to take control over their bodies and challenge the narrative of a racist, sexist society.

One of my favorite series, *The Discreet Charm of the Bougies* was created during a difficult period for Cox—she passed the threshold of forty and suddenly felt that she had reached an invisible stage. The once annoying abundance of catcalls and admiration from men Cox had experienced throughout her 20s and 30s slowly started dwindling away as she approached 40—she was left to wonder why and although Cox is still in this period, at the end of *The Discreet Charm of the Bougies* she

unravels a new level of consciousness: one that allows her to confront negative thoughts without allowing them to work against her, a place where she can truly be happy.

The photos for *The Discreet Charm the Bougies* were shot in Cox's Chappaqua home. Her inspiration for this series was Jacqueline Susann, a writer from the '60s who described the issues white women face in her book entitled *The Valley of Dolls*. What Cox found interesting is that whenever white women of a certain class had issues with addictions or dependency, they would end up in nice places like the Betty Ford Centre with a pool and servants. However, when Black women were portrayed to have similar issues, they would end up in "some crack house completely disheveled and look really fucking sad."

As a result of this, it motivated Cox to make a series depicting the reality of a different kind of Black woman than what was portrayed in the media—that is, a Black woman with a lifestyle more like hers. Cox had never lived in poverty, and the photos in her new series emulated the lifestyle she led. Frustrated with the Black woman always being cast as the loser or victim in the situation, Cox empowered and elevated Black women with her imagery. In the iconic image *Missy at Home*, Cox is pictured looking quite bored in a Christian Dior suit holding her trophy dog while being served by a white woman in full maid attire. This image creates an entirely new narrative that has rarely been explored. It shows that there are other ways to look at Black life.

Often Black lives appear in the media in a negative light, with Black people being painted as savages from the projects who commit crimes. This narrative is dangerous because it allows White people to use their fear of Black people as a justification for committing discrimination or hate crimes. Cox's work is a bold statement against this mentality, because she has shown that Black people are not a monolith. Instead, everyone is an individual who can have diverse interests and live in well-off communities.

Cox has a lot to say when it comes to race, gender, integration, experimentation and inspiration. Race is a concept that cannot be escaped, in both real life and her work. But when it comes to gender, Cox's opinion has shifted to the idea that gender should not consume her platform. It's a concept that should not take over her work.

According to Cox, integration destroyed the African American economic system that flourished after reconstruction. Before integration, Black owned businesses had been in abundance. Afterward, we saw a steep decline in the number of these establishments, along with many would-be Black entrepreneurs being left out of the economic cycle. There were financial as well as educational repercussions. Historically, Black colleges and universities have suffered greatly because of the most talented students deciding to attend predominantly White institutions such as Harvard or Yale instead of traditional HBCUs like Tuskegee, Bethune-Cookman or Spelman. Experimentation is integral in any artistic process, as it helps you elevate your craft. Although Cox doesn't believe in suffering merely for the sake of experimenting, she believes that trying unknown things to know how you want to work, what you want to do, and how you want to do it. Every new piece she creates contains an element of experimentation.

As an artist, inspiration is the driving force of your work, and for Cox it is everywhere. She gains a lot of insight from her personal life, and from history. As a human, history is the key to understanding the trajectory of things; it's a tool that keeps us from repeating mistakes. "Inspiration is important. It keeps you alive."

Cox's work has changed over time. In the past, her success controlled the emotion she felt—she was in a depressive state that could only be cured through the praise and recognition of her art. Negative opinions of her art sent her into funks that lasted for months on end. The ego was feeding her insecurity,

then negativity and competitiveness began overtaking her mind. It wasn't until she embarked on a transformative trip to Bali that her thoughts began to transform. A friend suggested a few books would change her life, including ones by Eckhart Tolle: *The Power of Now, A New Earth,* and *Living the Liberated Life and Dealing with the Pain Body.* The statements "Why are you waiting for the world to validate you?" and "You're asking crazy people to validate you" resonated greatly with Cox at that time.

Meanwhile, her recent work shows the influence of Benoit Mandelbrot, who discovered fractals in the '80s. Sacred geometry was prominent in countries such as Mali, Persia and Turkey—almost everywhere. Cox's fascination with the art form led her to create a world for people of color. It was a world that did not resemble anything she had seen or known about. Her exploration of this technique restored that child-like energy back into her work, bringing great joy.

Recently, art museums are showing more interest in Black artists, especially Black female artists. Despite the interest, Cox's work remains underrepresented in many permanent collections. But renowned private collectors like Elliot Perry, Peggy Croftout, Russell Simmons, and Damon Dash, all see something that museum-gatekeepers have missed: Incredibly profound and timeless culturally relevant artworks.

Derrick Adams b. 1970

Derrick Adams is the most humble star artist I have ever met. Our first encounter, though brief, made a lasting impression on me. In the summer of 2019, an art advisor, Anwarii Musa, invited me to an art party at the home of Swizz Beatz and Alicia Keys. I talk more about Musa's connections to the art world and his advisory firm Artmatic in Chapter 7. The scene there was incredible. It was a who's who in the art world filled with artists, curators, dealers, collectors, and other celebrities.

I found Derrick seated on a bench underneath a pair of portraits he had done of both Swizz and Alicia. I approached him. We exchanged a few words, and that was it. *Artnet* commissioned me for my second article with them, asking if I could interview an artist. A gallerist I knew then made a formal introduction, after which Derrick agreed to meet me for an interview.

That November, I went to meet with Derrick at his Brooklyn studio. As a critically acclaimed and multidisciplinary artist, Derrick Adams is known for his inventive portraits of Black subjects. As you will see, our discussion ranged from Derrick's creative vision to his advocacy for other artists, his ambitions to open an art residency in his hometown of Baltimore, and to his appreciation because about half of his collectors are Black.

THE GROWTH OF THE BALTIMORE ART SCENE

In my time talking with Derrick, it became clear that he had a special love for the Baltimore art scene. Considering Baltimore is his hometown, you would think this obvious. But there was more to it than that. Derrick has been revisiting Baltimore more and more often, particularly recently. "I'm from Baltimore, and recently I just became more interested in the creative culture of Baltimore," he said, "It's been prospering for younger artists—primarily artists of African descent."

It was clear in my time talking with Derrick that he drew contrasts between the experience of a Black artist growing up in Baltimore and a Black artist growing up in, say, New York where it's a bit of an unfamiliar process developing as an artist. He said, "Because these young artists are not in New York, they are away from the so-called market and able to develop in a way that they might not have been able to do here [in New York]. But they are still very close to New York, so they're still on the radar."

Derrick became interested in the growth of Black artists in Baltimore, and this led him to revisit the area more and more

often. In doing so, he hoped to be a part of that growth. As I would later find in my time talking with Derrick, this was, in part, because of his role as a facilitator for young Black artists. He hoped to push along the growth of Black artists in Baltimore as much as possible and used his expertise to act as a role model of experience in New York for budding artists.

That wasn't all Derrick set out to do, however. He also wanted to make people in New York more interested in the scene in Baltimore. As he put it, "I wanted to redirect some people who are interested in what's happening here in New York towards looking at what's happening in Baltimore since it's so close."

THE SUBJECTS OF DERRICK ADAMS'S PORTRAITS

The subject of any artist's work has always been profoundly interesting to me. As we continued to talk, I found myself interested to know more about the subject of Derrick's portraits. Remarking on the fact that, when I first met him, his portrait of Swizz Beatz and Alicia Keys was hung smack in the front room of their home, I pointed out that he rarely did portraits of celebrities. Who were the subjects of his portraits to him?

Derrick explained that the subjects of his portraits came from one of two sources, imagination or photo references. "If I photograph someone or source an image, I usually create composites, variations of different types of compositional poses. Normally the faces are imagined." This means that his portrait of Swizz Beatz and Alicia Keys was a departure from his norm.

The Brooklyn Museum asked Derrick to make a work featuring Swizz Beatz and Alicia Keys at the same time as they were being honored by the museum. Derrick stated that he was happy to do this, as he considers each of the subjects to be friends of his. Interestingly, Derrick was excited to take on this departure from his usual creative process. "I decided that it'd be interesting to make a portrait I felt represented them

but also aestheticized them in a way that made their image fall in line with some of my other work." In this way, Derrick fused his typical style with a new way of depicting subjects in his portraits. While the work ended up being a print, the original painting was gifted to Swizz Beatz and Alicia Keys.

Meanwhile, in his famous "Floater" series, Derrick used family members as the subject of his portraits. In the "Floater" series, Derrick depicts Black subjects swimming in a pool. Most of his subjects are floating along in pool floats while others are holding familiar objects such as beach balls. Derrick states that most of the faces used in this series are based upon members of his family.

THE INSPIRATION FOR DERRICK ADAMS'S PORTRAITS

As with other artists I have interviewed, I wondered about Derrick's creative process. Just where did he draw his inspiration from and how did he get into the mode of putting paint to canvas? Derrick found himself attracted to things in his daily space. "I pay attention to everything, from store windows to people in cafes talking, to people on the corner communicating. I like to think about surroundings as source materials."

Derrick explained that he is constantly looking at the aesthetics of people around him to draw inspiration. From focusing on how someone wears their hair to the way they communicate, he finds value in the smaller details and uses this to build the foundation of his work featuring Black subjects. "I believe that, as Black people, there are things we do, things that are common practice, that are also very complex and interesting forms of culture and cultural production," he says.

In my time viewing his work, I made particular note of three themes that he seems to revisit time and time again: the Black portrait, images of people in the pool, and the television. Wondering where he drew inspiration to repeatedly use these themes in his work, I asked him about it. He said, "When I

started the "Floater" series, I was thinking about alternative ways of representing Black figures in portraiture. Frankly, we all live in a postcolonial environment. As Black people, we shouldn't have to acknowledge it in everything we do."

Derrick clarified that a main source of his inspiration is found in using what he calls "Black radical imagination" to talk about how we live. "It's similar to how rappers express themselves," he said. "One of the strengths of rappers is the ability to imagine the most elaborate lifestyle. Eventually, if they're lucky, what they're talking about becomes reality." Derrick feels much the same way about his art. In his mind, if you want to depict yourself in a certain way, living with a certain level of freedom, it can happen, and that fact can be promoted through your art.

Derrick also noted the relation between his art and activist culture. As he noted, there is always a theme of perseverance in his work. He hoped this would provide a sense of normalcy that would fuel the generations of young Black people that followed. "We have to represent a certain sense of normalcy in order to stabilize the culture so that young people who are coming after us can look at themselves as fully dimensional humans—not always pushing against something, but basically existing in a way that's unapologetic and natural," he explained.

As for Derrick's inspiration for using television as a theme he revisits over and over, he drew on his time watching shows filled with a primarily Black cast and how those shows influenced him. These included: *In Living Color, The Cosby Show, A Different World, The Jeffersons*, and, *What's Happening!!*. Each of these shows depicted a primarily Black cast and, aside from having an enormous impact on Black culture as we know it today, these shows inspired Derrick, too. *What's Happening!!* was Derrick's favorite. He noted that the way it reflected young Black kids having fun rather than focusing on the economic situations of its characters was especially interesting to him as a kid, expanding his view on Black culture and life.

As we continued to discuss the influence of television on what Derrick would create, he remembered how he didn't feel as though there was any lack of representation of Black people when he was growing up. He remarked on times where he would tell his grandmother he didn't feel that there was any lack of representation for Black people on television shows. Rather, he felt there was a lack of representation in commercials. Commercials rarely depicted Black families living their lives, instead resorting to use primarily white depictions of life in America. Interestingly, he remembers specifically that commercials rarely showed Black people at the breakfast table. He feels, to this day, that that was more harmful and excluding than the representation of Black people in popular television shows.

So when did Derrick start to really notice a lack of representation? He noticed it more in institutional spaces. "I never felt in any way not represented. I think that's the case for most Black Americans. I think we start to understand exclusivity or unevenness when we get more into the institutional space, for example the Ivy League level." (Derrick received his MFA from Columbia University.) "That's when I think we start to realize the idea of being separated."

On Artists Who Inspire Him Today

Every artist has someone who inspires them. As they create their own art, they look around and appreciate those working alongside them to produce tantalizing pieces of art with something to say about Black culture and its place in the world. For this reason, I wanted to know who working today inspired Derrick. His answer was nearly immediate. "Mickalene Thomas is a very big inspiration to me as a peer," he said with admiration. "We attended undergrad together, so we're close, but that closeness is really coming from a sense of admiration and respect."

As Derrick listed other artists that inspired him such as David Hammons, Emma Amos, Adrian Piper, Ed Clark, Nicole Eisenman, and Bruce Nauman, I was interested to hear him mention

Bruce Nauman. Bruce Nauman, much like Derrick himself, is an interdisciplinary artist. I wondered if this had any relation to Derrick's work on the Met performance, "Finding Derrick 6 to 8."

Derrick explained that performance is always part of his vocabulary as an artist. In Derrick's mind, he always thought of art to ask the best method of execution was for facilitating the conversation that you want to have—it can be paintings, sculptures, photographs, or performances. The Met invited Derrick for a series that involved artists commenting on the work in the museum itself. "I picked Sol LeWitt, another artist I really enjoy," Derrick said. "My interpretation of his work is that it is about space, form, containment, and fluidity—things that I think are really significant in engaging with public space. As an artist and as a Black person, I thought about the idea of navigating these very rigid forms of containment in space and architecture."

Derrick measured both the horizontal and vertical lines that made up the LeWitt composition and making the reversible suit that camouflaged him within it. Derrick remembered that he stood in front of the wall for two hours at the museum, moving across and mimicking the formation of the lines as it related to the costume he was wearing. It was in this way that Derrick showed that this artist, Sol, focused on very formal aesthetics and less so with social-political concepts.

As a Black artist, Derrick states that he enjoys the extra level of content found in Black culture. This content facilitates something extra in important discussions in Derrick's mind, going beyond "just the formal" as he puts it. With a smile he continued saying, "I like the idea that we as Black people have this little extra something to add to the table of looking and seeing and experiencing, based on where we come from."

ACTING AS A "FACILITATOR" FOR YOUNG ARTISTS

In an interview that Derrick did with Orlando Live, he was asked to describe himself in one word. The word that he chose

was "facilitator." I was interested in this and, if the talks I've had with other people who knew him were evidence, this was in relation to his work helping young artists. I asked him how he decided which artists to help and why.

"That's always complicated," he began. "Usually I'm really open to helping all artists starting out. But it's like what Biggie said: 'When I get into the door and I leave the door open, it's up to you...' I'm like, This is what I can do. This is who I know. I can bring you here and introduce you to where I work—but after that it's on you."

I noted that this is, in fact, the difference between who makes it and who doesn't. The door may be open for you but it is your responsibility, as a young artist, to go in. Derrick agreed with this and said that, in the younger generation, he noticed a different level of professionalism. In his generation, coming from the 60s and 70s, Derrick has always been about "making it work," rather than focusing on the success associated with monetary gain. The younger generation, however, as Derrick seems to suggest, is more focused on monetary value over the fellowship and community of other artists.

STARTING AN ARTIST RESIDENCY OF HIS OWN

Derrick is on the board for several organizations, including Project for Empty Space, Eubie Blake in Baltimore, and Participant Inc. on the Lower East Side. Might he be starting an artist residency of his own? As it turns out, that's exactly what he's doing in Baltimore. He purchased some property there and is renovating it to form a retreat where everyone from Black visual artists and writers to culinary artists and technology-based individuals can come and thrive in a supporting peer setting.

When I asked him what the duration of the residency would be, Derrick answered confidently, "A month. There are studios that are being built and there are quite a few rooms in the house. So the goal is that in 2021, when it's all done,

we're going to start inviting people to participate, always including one person from Baltimore. The local person will help direct visitors to real, significant places that will inspire the work."

As Derrick continued to talk about his plans for his residency, his heart centered on Baltimore and its up-and-coming artists. He explained that the residency will be an artist retreat centered in Baltimore where people can come and reflect and learn more about the culture. He also stated that it was his goal to link up-and-coming artists from Baltimore with some resources he has found in more popular areas such as New York. "Maybe I can bring New York down to Baltimore so people in New York won't think Baltimore is so far," he suggested.

Staying Humble Despite Success

As our conversation drew to a close, I told Derrick that one thing that remained so consistent in any conversation I had ever had about him with someone who knew him was that, despite his having arrived at the pinnacle of success, he had remained so nice and so humble. How was this possible? He made it clear to me that one thing he was adamant about as an artist was that he shared the celebration with his peers, rather than being the only one celebrated for his success. "What I love the most is when I'm at an event or a party at someone's house and I look around and everyone in the room is doing something," he explained. "It's all Black people doing all these amazing things and I'm like, 'Wow, this is great'."

This is a driving force behind everything that Derrick does. In his view, young Black people should see that there are normal, consistent spaces where they can thrive as creative artists and celebrate their culture. Derrick clarifies that he has one focus in life—to just be. To make it work. To get the things that you want. "We're sitting on this pool float. We're thinking about life. We're thinking about nothing. We don't have to think

about something every day. It's a real human experience not to ponder on things constantly."

This view has translated into both his creative process and his art. Derrick thinks about what he wants to see whenever he turns the lights on in his studio. He says that he would much rather bring things that are "precious and valuable" into his creative space and use it to create his art rather than the bad and problematic. As you look at Derrick's art, I believe that you can feel this focus behind each stroke of the paintbrush. This makes such a powerful Black artist today.

Mario Moore b. 1987

There are thousands of people, often unseen in society, who quietly help everything be the way we expect it to be. For most of us Black people in America, we are those people, or they're our brothers, sisters, aunts or uncles. They go about their business, and the only time we even notice their presence is when something is wrong or we need something special. It is only when something becomes a problem that these invisible people transform into "essential workers," who keep our lives going, even possibly, amid global health and financial crises.

In 2019, Mario Moore meaningfully depicted these invisible workers in his art exhibition, "The Work of Several Lifetimes." It captured many of these people, African-American men and women who work at and around Princeton University. They are security guards, food services workers, and many others, who make a life for students and staff livable, even pleasant.

Moore's continually evolving style brings the lives of African-Americans to the forefront, highlighting not merely their struggles but also their successes. These works were created while he was the 2018-19 Hodder Fellow at Princeton. Meanwhile, each of the pieces in "The Work of Several Lifetimes"

reveals African-Americans that most people wouldn't see, but whose presence is vital to life at the university.

One painting in the series features a security guard, Michael Moore (no relation), who Mario Moore met accidentally when he visited the Princeton University Art Museum. Mario entered the museum and struck up a conversation with the security guard to find a place to get his haircut. In his own words, "My approach to the work was very different from anything I've ever done before. Because oftentimes working with resources and people that I already know, like doing these paintings and things. I wasn't walking up to random people, I wasn't you know doing that kind of thing but this was a very different process."

After a few minutes of conversation, Michael Moore agreed to be a subject for a painting series. The piece featuring him shows him holding open a door leading to a room filled with art. Behind him is a gallery of works of art that doesn't exist at the Princeton museum, but features works from some artist's heroes. Viewers get the distinct feeling of being invited by a welcoming security guard, who is Black, to a gallery of fine art.

When he was growing up, Moore's father worked as a security guard at the Detroit Institute of Arts. Once he'd become a Hodder Fellow at Princeton, Moore knew that he wanted to highlight the small, but vital, Black community of the prestigious university.

Another major influence is his grandmother, Helen Moore. "I think probably one of the most important things just as background is like my grandmother," he said. "I say that because she's an education activist and she's been that all my life. That's pretty much all I've known her as but how her philosophy and what she does, she often used to take me to all these marches but all that leads into my work because of my grandma."

Moore was born in Detroit in 1987. His mother is an artist who inspired him to learn more. He also learned how to paint from a family friend, Richard Lewis, who took a summer to

show him how to work in oils. His mother works at College for Creative Studies, and she supplied him with books that exposed him to both the great masters and to modern African-American artists. He found a passion for Caravaggio. This appreciation for the modern and the classical shows in the way he creates his subjects and the background of his paintings.

Being aesthetically striking, his works speak to the African-American experience and how Blacks interact with the larger society. "Basically, what I'm trying to entice within the work is to say that, these American ideals, this thing of democracy, this thing that everybody's equal is something that's placed upon us that we have that African-Americans have no say in," Moore said. "Well, then you have a shadow that's kind of cast over the figure which is the shadow of anybody who's standing in front of the painting."

While not overtly political, the pieces in *The Work of Several Lifetimes* show a sensitivity to the Black experience in America by making visible, making art, from the invisible people who make life better.

For each of the pieces shown at *The Work of Several Lifetimes*, Moore sat with the subjects and talked with them. He took about a half-hour with each, doing life drawings, and learning the personalities of his subjects. He would then take photos to work from later. These conversations enabled him to let the more complete person show through the paintings.

With almost every painting, the person is placed into a somewhat fabricated background. While informed by their real-life jobs, such as in the university's canteen or in a coffee shop on the grounds, Moore added background images that build the artworks from simple portraits to complex stories. In fact, each piece tells three stories: the story of the artist, the story of the subject, and the story of African-Americans who are so vital to life in the United States, but who are often unseen and unacknowledged.

All the pieces in *The Work of Several Lifetimes* are deeply emotional. In many cases, the piece evokes happiness, but not all. Several speak to quiet emotions, such as boredom or simple familiarity. Others give a feeling of camaraderie and friendship.

To many viewers and even to the subjects themselves, this display of quiet emotion is Mario Moore's greatest strength. His subjects appear ready to step off the canvas and start a conversation with you. More than "realistic," each of these pieces is "alive," the subject feeling vibrant with a Rembrandt-style of life that few painters achieve.

Tschabalala Self b. 1990

In only a few short years, Tschabalala Self has made a name for herself in the art world, her unique and uncompromising style encouraging people to change how they think about and see Black bodies, emphasizing beauty above all else. Equal parts nostalgic and erotic, her work makes bold statements about ideas and preconceptions of Black people, namely Black women. In her artwork, all assumptions—about both how we should perceive her subjects and about the materials that should compose art—become secondary to the ideas she is expressing.

After completing her BA at Bard College, Self attended the Yale School of Art, where she earned her MFA in Painting and Printmaking. Shortly thereafter, in 2015, the Schur-Narula Gallery in Berlin exhibited her work in her first solo show, which she followed up with a 2016 solo show at New York's Thierry Goldberg. Since then, museums worldwide have procured her work, and she has contributed to the permanent collections at Los Angeles' Hammer Museum, Miami's Perez Art Museum, Miami's Rubell Family Collection, The Studio Museum in Harlem, El Museo del Barrio, The Bronx Museum of Arts, the Brooklyn Museum, the Museum of Modern Art, and the Museum of the City of New York.

There is perhaps no piece that Self has produced that is more emblematic of her style and sensibilities than *Milk Chocolate*, a 2017 mixed-media work for which she used acrylic, watercolors, flash, crayons, colored pencils, oil pastels, pencils, hand-colored photocopy, and hand-colored canvas, combining all of her materials onto a single 96" x 84" canvas. *Milk Chocolate*, which portrays a crouching nude Black woman from behind, is a celebration of the form of the Black body, the subject's wide smile a declaration in no uncertain terms of confidence and pride.

Of the substance of her art, Self says, "The work is political because it's politicized; politicized bodies are featured in the work. I'm a political person because if I wasn't a political person, that would affect my safety and my well-being in the country. But that's not why I'm making the work. I'm making the work to leave a document of my experience, leave a document of the experience of people who are like me."

In June 2019, Self's *Out of Body (2015)* went up for auction at Christie's and garnered $471,322, shattering the pre-auction estimates of $76,430, for a whopping +3,000% return on the original sale price. Only four months later, at another Christie's auction, *Sapphire* sold for $487,000. This shows her career striking in the breakneck rapidity with which it has developed. Prior to the auction, in 2017 *Forbes* included her on their "30 Under 30" list, quoting Los Angeles art collector Dean Valentine, who said, "I like the complex sexiness of her work. It's kind of an anti-Picasso."

Self was born in Harlem, which heavily influenced her best-known series, *Bodega Run,* and resides in New Haven, Connecticut.

Chapter 3

Art Museums: Membership has its perks

Museums and Exhibitions

To learn about art, and to deepen your understanding of a specific artist or group, you might make a habit of visiting museums—and attending exhibitions. Museums allow the viewer to experience art up close, transform their thoughts on specific artists or pieces into words, and draw a cohesive conclusion regarding the meaning of the art in question. These havens are a forum of aesthetic and sociopolitical discussion, and a platform for curating one's artistic taste. Exhibitions are paramount to becoming a more informed and engaged collector.

35,000 museums exist in the United States. While there is boundless knowledge to take in, and a wealth of art on display, I urge contemporary art viewers and collectors to add the following places to their list of must-sees: the Metropolitan Museum of Art in New York City, the Art Institute of Chicago, the Detroit Institute of Arts, the High Museum of Art in Atlanta, the Institute of Contemporary Art in Boston, and the Contemporary Arts Museum Houston and any museum in the city in which you live. These locales offer expansive insights into Black

contemporary art, all while hosting meaningful exhibitions that shed light on specific artists and ideologies.

Museums are no doubt educational; however, they also provide a sense of community. Perhaps they bring validity to the artist's career, allowing them to propel themselves further into the industry. Whether the artist in question is emerging or established, an art exhibition is fundamental to understanding the progression of the person's career (alongside the movement with which they associate), to connecting with the community, and to increasing public awareness and fundraising, paving the way for the future of our industry.

The Metropolitan Museum of Art.

An Introduction to the Met and its Historic Exhibitions

The Metropolitan Museum of Art, commonly known as the Met, is the largest and most extensive art museum in America and one of the leading museums in the world. With over 6,479,548 visitors to its three locations in 2019 it is the fourth most visited art museum in the world. It divides its enormous collection of over two million works among 17 different curatorial departments.

Throughout the 19th century, the museum continued to grow. The purchase of the Cesnola Collection of Cypriot art included pieces from the Bronze Age until the end of the Roman period. This acquisition helped solidify the Met as a major source of classical antiquities. In addition, the museum inherited 38 paintings by American artist John Kensett after his death in 1872, and pieces by Edouard Manet in 1889.

By the 20th century, meanwhile, the Met had gained a reputation as one of the world's greatest art centers. In 1907, the museum acquired a piece by Auguste Renoir. Then, in 1910, it made history by becoming the first public institution to accession a work by Henri Matisse. The Met obtained the infamous

ancient Egyptian hippopotamus statuette nicknamed "William" in 1917. Today, the museum has 26,000 pieces of ancient Egyptian objects on display, making it the largest collection of Egyptian art anywhere outside of Cairo. Their 2,500 European paintings comprise one of the best collections in the world. The American wing holds the world's most extensive collection of American paintings, sculptures, and decorative arts.

The museum holds a wide variety of collections including arms and armor, the arts of Africa, Asian art, costume, Islamic art, modern and contemporary art, photographs, the Robert Lehman collection and more. At any given time, there are tens of thousands of objects on display in the two million square foot building.

The Met is justly famous for its exhibitions; let's look at some of their most visited exhibitions of all time.

❖ *Heavenly Bodies: Fashion and the Catholic Imagination*—With over 1.6 million visitors, this exhibition belongs at the top of the list. Curated by the costume institute at the Met Fifth Avenue and the Met Cloisters, this exhibition explored the relationship between fashion and medieval art from the Met collection. It examined fashion's relationship with the devotional practices and traditions of Catholicism. They filled the exhibition with papal robes, accessories from the Sistine chapel, and early 20th century fashions.

❖ *Treasures of Tutankhamun*—With 1,360,957 visitors, this exhibition explored the treasures kept in the tomb of the young pharaoh Tutankhamun, who lived through a magnificent period of ancient Egyptian art and history. Treasures from Tutankhamun's childhood to unique works of art were displayed.

❖ *Mona Lisa*—A loan from the Louvre, the work of art arrived at the Met in 1963, where it stayed for approximately 3 weeks. During that time, 1,077,521 visitors lined up to see the impressive piece during its brief time at the museum.

The overseas trip was highly opposed by many French people due to concerns for the precious painting's preservation; despite this, the piece made the journey safely.

❖ *The Vatican Collections*—Attracting 896,743 visitors, this exhibition comprised works drawn from the Vatican museums, Saint Peter's and its Treasury, the Apostolic Palace, and the Vatican Library. This collection is one of the most influential in the Western world, as it represents the history and tradition of the papacy.

❖ *Painters in Paris*—Paris has always been an artistic hotbed, and this exhibition attracted 883,620 visitors. During the first decades of the 20th century, France was home to many influential artists, becoming the center of Modern art. The exhibition displayed over 100 pieces from the School of Paris, including masters such as Braque, Chagall, Dubuffet, Matisse, Modigliani, Miro, and Picasso. It was a great depiction of Modern Paris.

❖ *China*: *Through the Looking Glass*—This exhibition investigating the impact of Chinese culture on Western fashion brought in 815,992 visitors. The Costume Institute collaborated with the Department of Asian Art to reveal how China has inspired the fashionable imagination for centuries. High fashion pieces were presented in contrast with Chinese costumes, paintings, films, and other art to reflect Chinese imagery. For decades, western designers such as Paul Poiret and Yves Saint Laurent have been enchanted by objects and images from the East, incorporating these influences into their own designs. Over 140 haute couture and avant-garde ready-to-wear pieces were on display.

Now that we've explored a few of the most well-known exhibitions at the Met, let's explore a current one. *The New Ones, Will Free Us* is an exhibition designed by Kenyan-American artist Wangechi Mutu. Before this exhibition, the Met's historic façade

will be adorned with Mutu's free-standing sculptures that will transform the once empty niches. Mutu has created four bronze sculptures titled *The Seated I, II, III, and IV.* The pieces critique the gender and racial politics, referencing a motif prevalent in both Western and African art, the caryatid. This is a sculpted figure that is typically female and serves to support.

A caryatid is traditionally confined to its role as load-bearer, yet Mutu challenges this with a feminist take that relieves the caryatid from its traditional duties. Perhaps this work can be seen as a commentary on the responsibility that women, Black women in particular, face in society. Mutu's decoration of the pieces draws inspiration from the embellishment of high-ranking African women, from the coils that cover the figure's bodies like armor to the beaded bodices and necklaces. The figures are authoritative, investigating the relationship between power, culture, and representation.

Art Institute Chicago

The Art Institute of Chicago and Mickalene Thomas' *Rumble*
Founded in 1879, the Art Institute of Chicago is one of the oldest and largest art museums in the United States. In Chicago's Grant Park, the museum is widely recognized for its curated art collection, which attracts approximately 1.5 million people annually. Its collection has 11 departments with iconic works such as Pablo Picasso's *The Old Guitarist* and Edward Hopper's *Nighthawks.* The permanent collection contains over 300,000 pieces of art with over 30 special yearly exhibitions that highlight the aspects of the said collection and present innovative scientific research.

As a research institution, the museum has a conservation science department, five conservation laboratories, and the Ryerson and Burnham Libraries, one of the largest art history and architecture libraries in the United States. Although the museum was already massive, there have been several additions

due to the growth of the collection. One of the most recent additions, the Modern Wing designed by Renzo Piano, opened in 2009 and increased the museum's size tremendously, making it the second-largest art museum in the country after the Metropolitan Museum of Art.

Meanwhile, the art collection at the Art Institute of Chicago encapsulates over 5,000 years of human history and cultural expression from all over the world. The museum holds pieces from early Japanese prints to contemporary American art. In fact, it is recognized for having one of the finest collections of Western paintings in the United States. In addition to all this, they have an extensive collection of African, American, modern and contemporary art.

Recently, Black contemporary art has become a commodity in the art market and the Art Institute has acquired more of it accordingly. One piece in particular that's worth focusing on is Mickalene Thomas' *Rumble* from her brawling spitfire wrestling series. Mickalene Thomas is an American-born artist now operating out of New York. She creates striking paintings and photographs of Black women that explore the concepts of female identity and beauty.

Heavily inspired by art history and pop culture, Thomas' work references sources from 19th century French paintings to 1970s Blaxploitation films. She has been influenced by people from Henri Matisse to Pam Grier. Her paintings are based on her own photographs, which she then covers in rhinestones, collage, acrylic paint, and enamel. Influences from traditional Western paintings can be seen in the mimicked poses of her Black subjects. These protagonists of Thomas' narratives are often surrounded by outrageously patterned walls.

This pattern is also true in the aforementioned *Rumble,* from 2015. The piece is a collage composed of cut-and-paste photos, tape, paper, and acrylic paint. Her powerful images continue to celebrate the diverse beauty and body types of Black women.

Dia Detroit

Detroit Institute of Arts Hosts New Exhibition Featuring Selections of African American Art

The Detroit Institute of Arts has one of the largest and most prominent art collections in the entire country. As a Detroit native, I've been visiting this museum for decades. In Midtown Detroit, Michigan, DIA is listed among the top six museums in the United States thanks to its collection of works from all over the world. With regular events and new exhibitions like *Detroit Selects* popping up regularly, DIA is a positive force for art in the Detroit community.

EVENTS

The Detroit Institute of Art hosts Friday Night Live, a weekly selection of free performances by both local and international musicians. They also air a selection of international and art cinema at the Detroit Film Theatre. DIA is a perfect place for families, with daily family events, workshops, and free gallery games. School field trips and other groups can also schedule personalized studio classes for a deeper dive into all the art that the museum has to offer.

COLLECTION

DIA offers free public guided tours to teach people more about the works of art on display at the museum. For a more immersive experience into their collections, DIA offers multimedia tours with a handheld device. Their Arts and Minds Lectures also feature conversations about different topics regarding art and culture from prominent artists, historians, and curators. The *Rivera Court* is a room with Detroit Industry Murals painted by Diego Rivera, 1932-1933. Often compared to Michelangelo's *Sistine Chapel*, for its scale and importance of period specific grand room encompassing murals.

DIA has many rotating art exhibitions that feature different artists and periods of art. Their exhibition featuring Dutch and Flemish Prints and Drawings from 1550 to 1700 lasts through July 26, and they also feature an exhibition of Bruegel's "The Wedding Dance." It features three important works by Frida Kahlo and Salvador Dali in an exhibition through September 27, showing how the artists created their own surrealist worlds.

DETROIT COLLECTS EXHIBITION

One of the Detroit Institute of Art's most prominent exhibitions is the *Detroit Collects: Selections of African American Art from Private Collections*. This explores the rich and vivid history of the collection of African American Art in the Detroit region by private collectors. Noted African-American artists Romare Bearden, Charles McGee, Al Loving, Mario Moore, and Alison Saar are all featured in the exhibition.

Detroit Collects also shows how local collectors' interest in the diverse media, genres, and subject of African American culture led them to collect artwork by Black artists. A catalog is available alongside the exhibition to view the different works of art online. Highlights from the exhibition can be found on dia.org/detroitcollects.

High Atlanta

The exhibition *Something Over Something Else*—a masterpiece in The High Museum in Atlanta

According to a *Bloomberg News* study, the number of Black households in Atlanta earning at least $200,000 a year is up 145 percent since 2010. Meanwhile, the High Museum of Art is the place to go for art in Atlanta. Since 1905, it has offered art lovers the opportunity to get lost in exhibitions highlighting some

of the greatest artists of the past century. One exhibition that stood out is Romare Bearden's *Something over Something Else,* which took place in the High Museum of Art from September 2019 to February 2020.

A JOURNEY TO ROMARE BEARDEN'S LIFE

The exhibition in the High Museum of Art was addressed to the colorful profile series of Romare Bearden's life. Romare Bearden himself got the inspiration for the exhibition after an interview with a famous New York magazine. Back then, he was directly asked to put his profiles into an exhibition and make it available to the visitor. What at first seemed to be an ordinary interview later became an inspiration for Bearden to turn the idea into reality. Now, decades after the death of the artist, his work is still alive.

A COLORFUL EXHIBITION

There is a deeper meaning as it relates to Romare Bearden's life experiences; the colorful appearance seems to stand out the most. In the exhibition, he communicated with colors, trying to convey each message through the painting. This not only makes the exhibition a colorful experience; it brings moments of his experience to life again. With unique styles and colors, the exhibition takes visitors on a journey through his adventurous life. From basic events like a train ride, to meaningful events like a funeral, his journey was fascinating. Every one of these events became a piece in the exhibition, revealing the different sides of his life. For the lovers of his art, this exhibition at the High was a must.

IN MEMORY OF ROMARE BEARDEN

For the High Museum of Art, the exhibition was in memory of a talented artist. For the people of Atlanta, they got a peek into some masterpieces Romare Bearden created.

ICA

The Institute of Contemporary Art (ICA), Boston is an art museum and an exhibition space in Boston, Massachusetts, USA. It was founded in 1936 as the Boston Museum of Modern Art. In 1948, the institution changed its name to ICA after losing association from its sister partner, New York's MoMA. The current ICA building was constructed in 2006 using Diller Scofidio + Renfro design. The museum and exhibition space focus on exhibiting modern art championing innovative approaches to art. The institution has gained a large reputation and public image from identifying creative artists and providing them an avenue to nurture their skills. For the last 80 years, the ICA has played a critical role in presenting contemporary art such as films, visual arts, literature, and video to encourage an appreciation for contemporary art.

Arthur Jafa's 2016 video *Love Is The Message, The Message Is Death* is a previous exhibition portrayed by the ICA, showcasing video as a form of visual art. Arthur is an American artist, cinematographer, and film director, who created the seven-minute clip to trace African American history and experience. The video combines various sources such as pop videos, police cameras, sporting events, citizen videos, and TV news. It compiles distinct moments, such as a civil rights march; Martin Luther King waving at people from the back of a car; former president Barack Obama singing his *Amazing Grace* eulogy for the nine Charleston parishioners killed by a white supremacist; a police officer using excessive force on a teenage girl at a pool party in Texas; and Beyoncé's music video "7/11." Jafa intersperses these images by the footage he shot featuring his mother dancing, his daughter's wedding, and a collection of his past works. Set with searing highs and lows of Kanye West's gospel-inspired hip-hop track *Ultralight Beam* playing in the background. The video also features a recurring image of the sun. Jafa used the

sun in this video to act as an appropriate scale to weigh the daily actions going on in people's lives.

Love Is The Message, The Message Is Death is a excellent example of the video—as contemporary art. Video art uses video and/or audio data while relying on moving pictures. Jafa's video is an installation video comprising different assembled pieces of video with assemblage and performance art. The video combines design, sculpture, and architecture, digital, and electronic art ranging from civil rights marches to President Obama's eulogy. The video captures actions and describes events vital in illustrating the history of Black Americans in 21st century America. Thus, *Love Is the Message, The Message Is Death* is a piece of video art that replicates the power, beauty, and alienation of Black music and experience.

Contemporary Houston

The Contemporary Arts Museum in Houston and *Nari Ward: We the People*

Founded in 1948, the Contemporary Arts Museum Houston (CAMH) is in the Museum District of Houston, Texas. This museum is strictly dedicated to bringing contemporary art to the public. As a free institution, the Museum is committed to showing the most inspiring international, national and regional art of our time. They aim to engage the public by presenting new art and demonstrating its relation to modern life through exhibitions, lectures, publications, and a variety of other educational programs.

CAMH is based in an impressive stainless-steel building designed by award-winning architect Gunnar Birkerts that opened in 1972. The museum emerged controversially by opening with an exhibition called *Ten* that featured several artists who worked in non-traditional media. Throughout the 70s, CAMH continued to push the boundaries by introducing

exhibitions such as John Chamberlain's *Dale Gas,* which was one of the first presentations to survey Hispanic artists in the United States.

In the 80s, the Museum grew rapidly and expanded its exhibitions by including installations for performance art and contemporary still-life paintings. Since then, this innovative series has featured over 175 different exhibitions. By the 90s, the Museum had included art that was created within the past 40 years, and internationally recognized art and artists. The Museum's two floors of gallery space are used to display six to eight exhibitions annually.

An interesting exhibition at CAMH is *Nari Ward: We the People,* the first museum survey in Texas of the artist. Ward was born 1963 in St. Andrew, Jamaica and currently resides and works in Harlem, New York. He is known for his sculptural installations created from discarded material collected in his neighborhood. Ward has been known to repurpose objects like baby strollers, bottles, doors, cash registers, shoelaces, and more. He uses these sculptures as commentary on the social and political issues surrounding race, poverty, economic disenfranchisement, democracy, and culture. The meaning of his work is left open, forcing the viewer to project their own interpretations.

Nari Ward: We the People is a familiar phrase from the preamble of the constitution of the United States. It evokes the values that the constitution aims to achieve—democratic governance, justice, freedom, and equality. In the exhibition Ward spells out the phrase using colored shoelaces. This exhibition raises the question "who are we?" This leaves the audience to generate their own thoughts, potentially exposing the disparities within the phrase itself. Ward's work is powerful, transformative, and serves as a catalyst for change.

Chapter 4

Sometimes free really is free: Art Galleries

Art Galleries: A Place to Look and Learn About Art

There's a structure for almost every facet of society, and that includes art galleries. There has been a system in place since buying and selling art has been around; this will not change soon. At first, visiting an art gallery may seem rather intimidating. They are typically large empty spaces with minimal distractions and controlled lighting that best showcases the art in question.

They are notorious for being impersonal spaces, so don't be surprised if the receptionist doesn't acknowledge your presence when you walk in. Many art galleries are designed to mimic museums, but despite the similarities there are a few distinct differences. As an art enthusiast learning about art with the intention to be collector, it's important to know these differences.

The first major difference is that, unlike museums, art galleries are businesses that sell the art they display. Galleries then use the money made during a sale to cover operating expenses and generate a profit. They often have a certain criterion for the artists who are featured in the gallery or who use a shared

style, technique, medium, etc. Ultimately, artists are typically paid a portion of the purchase price of the artwork, minus the percentage taken by the gallery.

It's also crucial to note that many galleries operate in specific categories of art. Some may specialize in contemporary art, while others focus on European classics. Galleries often focus on one artist for an extended period by presenting month long exhibitions to one or a small group of artists. These exhibitions are then promoted to potential buyers via ads, phone calls, and openings. Although galleries are a great place to learn about art, ultimately, they are a business looking to promote and sell the artwork of their artists.

When entering an art gallery, it's likely that you'll notice white walls, white cube designs, and quiet spaces. This is purely a marketing tactic many galleries use to convey an heir of affluence. These establishments are designed to attract elite, educated, and sophisticated individuals and institutions. This façade creates a psychological barrier that discourages people who do not fall in the 'elitist' category from attending gallery showings. And ultimately, from collecting the art.

In addition to all this, galleries are the gatekeepers to the art on display, and have full reign to decide who procures the pieces. Although buying from galleries gives you access to exclusive work, the barrier to entry is significantly high. Museums are often pushed to the front as a reputable buyer followed by collectors who have a history of purchasing the upper echelon and finally everyone else...that is if anything's left.

Although this can be disheartening for avid art lovers who don't fit into the preferred categories, this isn't a reason to feel discouraged, as galleries aren't the only gatekeepers in the art world.

Alitash Kebede—A Passion for Art and an Eye for Artists

Within the art world, Alitash Kebede has made a name for herself spotting major artists before they rise to fame

As a collector and gallery director, Alitash has established herself as a force in the art world, not only through her commitment to the community but also through her sharp eye and her keen sense of what's next. Dating to the 80s and 90s, she proved repeatedly her natural intuition for identifying artists whose profiles were on the rise. She has cemented her reputation for informed insights about art, while at the same time, she has made herself a model for what is accessible to all new collectors, proving through her early successes that substantial windfalls *are* possible.

Early in her career, Alitash launched her art gallery out of passion, learning rapidly what drew collectors. She sold many Romare Bearden and Jacob Lawrence pieces. Meanwhile, despite the attention that the late Ed Clark garnered, his art moved slowly. This was the era *before* Clark had become a household name, his abstract paintings far from the hallmarks they have since become. In retrospect, her enthusiasm for his art seems indubitably prescient, a combination of what she thought of him herself and how she saw others reacting to him, even if they were not purchasing his pieces. As she explains it, the audience that was showing up to her gallery at the time was far from conventional.

"I was exposing people who did not pay much attention to art before," Alitash says. Specifically, she mentions a Hollywood star, at the time a young aspiring actor, who told her that despite studying art appreciation in college, he had not learned about any of the artists that he was seeing in her space. Artists like Bearden, Clark, Norman Lewis, and Emma Amos were revelations to the young actor, and his experience was

not entirely unique. The private art dealing that she was doing entailed as much education as dealing—a responsibility in which she revealed.

Of this responsibility, Alitash is forthright with her words, saying her duty as a Black collector focusing on Black artists is to serve as a steward of the culture and heritage. She sees it as a moral imperative, one that people *and* governments should undertake, creating a record of the art, music, literature, fashion, and poetry that define each era by shaping the past. She is a chronicler, and her passion for her work is immediately evident, the immense worth of her undertaking something that she views as both obvious and foundational to all of her efforts.

Everything about Alitash's beginning was unorthodox, including her early efforts as an exhibitor. Recounting her first group exhibition in 1982, she rattles off some artists whose works she included: Vincent Smith, Romare Bearden, Skunder Boghossian, Jacob Lawrence, and Z. K. Oloruntuba. The exhibition, fitting for the maverick's journey she has taken through the art world, was at her one-bedroom apartment in West Hollywood, a 1930s Tudor-style residence, instead of a gallery or a museum. When she put on her second exhibition, it revolved around Mel Edwards, a sculptor who, she says, may have accrued five or fewer patrons at the time. Today, his sculptures sell for six-figure sums and up, and he makes frequent appearances at world-class museums. In the early 1980s? She closed *zero* sales at his exhibition—every sculpture that went un-selected was like a gold bar left buried in an underground vault.

Born in Ethiopia, Alitash grew up appreciating art. She worked in the music industry for a time, taking a job at Atlantic Records before deciding to shift into art, disillusioned with the disco craze, which, she says, she "hated with passion." Trekking from Los Angeles to New York City, she took up residence in Tudor City, meeting multiple artists and immersing herself in the community. Her intentions were clear: she wanted to raise

up Black artists, creating more excitement around their work and encouraging collectors, new and old, to consider making purchases. One artist after another, she found a path for herself, feeling more at home in art than she ever had in music. What had seemed like a risk ended up being the decision that made the most sense.

When she was starting out, Alitash catered to first-time buyers, introducing lawyers, doctors, writers, actors, film producers, music producers, and advertising executives to the art world, even selling a sculpture to one of history's best-known singers and music industry pioneers. She generated buzz about her art collecting through word-of-mouth, taking part in a wave of creativity and change in the entertainment industry, connecting with up-and-comers who have since ascended to the heights of success.

Perhaps because of the confidence with which Alitash goes about her duties as a collector, she opened the art world up to people who are anything but insiders, spreading Black artists' work more widely than someone less convinced of their mission could. She relates one story about a move she was making into a new duplex, and to bridge the gap between the old rent and the new, she offered a dry-pigment of a Ed Clark in trade. It is stories like this one, so unassuming, that characterize her career, while also driving home the primary importance that Clark has played in her career, pushing her forward and making appearances at every juncture, from her days as a private dealer to the present. As a tribute to Clark's career, she has even paired with young filmmaker and UCLA Film School graduate Andrew Rosenstein on a documentary about the virtuoso painter.

When Alitash launched her debut art salon called Alitash Kebede Contemporary Art, it was out of her dream apartment. The apartment was perfect for her purposes, but it was an apartment. She had not stepped into a gallery and taken it over ready-made; she needed to make it work on her own. Little

by little, she did just that. She saw the wonder in the art that she was seeing and acted on it. Every move she was making turned out to be leading toward the career she eventually created for herself. The apartment resembled Peg Alston's Central Park West apartment and gallery, atypical for Los Angeles, and the rest fell into place for her because of her willingness to pursue Black artists with whom she resonated. She says that she remained optimistic about everything that was going on back then, and this optimism was well-founded, foretelling the illustriousness that would follow so many of the artists she had picked out—artists whose works were there for the taking, available to anyone at a bargain price, the value of their works skyrocketed in the decades since.

Chapter 5

On Art fairs

There's something synergistic about the elusive *art fair*. These celebrated, bustling events represent a gathering place—a forum where collectors and viewers can experience art from a number of galleries, all in one place, and communicate directly with the exhibitors.

Art fairs drive sales, fuel discussion, and represent an ideal way for artists to promote their work and agendas, consequently cultivating a wider audience. They allow emerging talent to showcase their art in front of some of the world's premier museums, galleries, dealers, agents, critics, curators, consultants, and other players. In turn, art fairs benefit collectors, who can consume vast amounts of art in a single place there, and give galleries located outside metropolitan areas the means to reach the desired clientele.

Art fairs are the ideal environment for networking. These events provide a place where artists can share their work, where they can teach others about their own progression, and where collectors can make meaningful purchases and glean insights into where the market might be headed. Galleries are the gatekeepers, but once inside, opportunities abound for all parties. These are bustling, crowded events, where industry leaders and emerging talent can join forces, put new artists and trends on their radar, and discuss the future of the industry.

Top fairs attract 20,000 to 40,000 global art aficionados, including art students, and are essential for those who hope to progress in their profession. This means exhibitors must be patient and personable, and willing to connect with dealers who have well-established tastes and preferences, not to mention intuition for what just might be the next big thing.

Among the nation's most renowned contemporary art fairs are the lauded Art Basel in Miami Beach, Frieze New York, and EXPO Chicago.

Art Basel, Miami Beach. Picasso Baby.

In 2013, Jay Z released the album *Magna Carta*, featuring the song "Picasso Baby." My favorite line in the song is, "Twin Bugatti's outside of Art Basel. I just wanna live life colossal." It really speaks to how big this art fair has come since its Miami iteration opened in 2002. The fair the song referenced, Art Basel, is an international art fair that is now staged yearly in Basel, Hong Kong, and Miami Beach. By collaborating with the local art institutions in each host city, Art Basel helps communities grow their art programs while giving artists and collectors a platform to come together to buy and sell artwork, not to mention, network.

Started in 1970 in Switzerland, Art Basel's fairs have drawn thousands of visitors every year that include prominent figures in the art world. In 2019, the Miami Beach Art Basel fair presented 269 international galleries from 29 countries, with 20 of those galleries showing in Miami Beach for the first time. In this section I will go over everything you need to know about the Miami Beach Art Basel fair, including ticket offerings, and an example of an off-site exhibit and an on-site talk.

Types Of Galleries

GALLERIES

The Miami Beach location of Art Basel features leading galleries from all over the world, including North America, Latin America, Europe, and Asia. The main sector of the fair features significant works by leading international artists. These artists range from the established masters of Modern and contemporary art to the newer up-and-coming artists. One of my favorite pieces, from the 2019 edition, was Beauford Delaney's "Untitled (Greene Street), 1950," shown by the Michael Rosenfeld Gallery.

MERIDIANS

The Art Basel fair also has a specific section for large-scale projects that don't conform to the traditional layout of art fairs. In last year's Art Basel fair in Miami Beach, viewers could witness a video directed by Theaster Gates, "Dance of Malaga," 2019.

NOVA

The Nova sector presents works that were created within the last three years. These works are created by one-to-three artists, with last year's fair featuring Amoako Boafo's "Cobalt Blue Earring," 2019.

POSITIONS

The positions sector displays galleries that showcase the unique solo presentations of emerging artists. The 2019 fair showcased such works by Tau Lewis, the self-taught Canadian artist who sculpted the piece "Cooper Cole" out of recycled leather, wire, recycled poly fibres, rebar, hardware, stones and dollars, and seashells.

SURVEY

This sector features galleries that highlight historically relevant artistic practices, such Pippy Houldsworth Gallery's decision

to show Faith Ringgold's "Slave Rape #1: Fear Will Make You Weak," 1972, which reminds us of America's brutal racial discrimination against African Americans.

EDITION

There's also a sector that features editioned works, prints, and multiples like those of acclaimed sculptor Leonardo Drew, who published "CPP6," along with Crown Point Press.

KABINETT

Lastly, the Kabinett sector comprises thematic solo presentations by both modern and contemporary artists. These presentations are displayed in a separate section. At the 2019 fair, the Kabinett sector featured works such as Torkwase Dyson's "Hot Cold (Black Water 1919)," which showcased her bold abstract work.

TICKETS

Tickets to Art Basel can be purchased either online or at the box office. Ticket choices range from a day pass to the Premium+ Card, which provides you with a four-day pass and exclusive access to other events. A Day Ticket is valid for one public day during the public opening hours. The Permanent Ticket provides admission for one person for all four days. The Combination Ticket is a Day Ticket that gives you access to both Art Basel and Design Miami. The Premium+ Card comes with exclusive access to the Art Basel Vernissage and all public days. In 2019, it also gave you a free Art Basel book with a bag, priority tour bookings, and free access to select museums in South Florida.

BUYING ART AT ART BASEL

Art Basel draws many of the world's biggest collectors to purchase artwork from the featured artists. While many works of art sell for prices in the million-dollar range, there are plenty of pieces that priced below $50,000, so buying art at Art Basel is

accessible to all collectors. But getting there early gives you first look at the works since many sales are made on the first day.

VIP STATUS
Art Basel has a global VIP Representative Network that creates and maintains relationships with art patrons worldwide. The 29 art experts who compose the VIP Representatives provide VIP guests with exclusive access and services that help provide a personalized experience at the fair. These VIP guests include private collectors and leading figures, and curators and art advisors who are engaged with the international art world.

VIP tickets are invitation-only, providing you with a special VIP status for the duration of the art fair. Those given First Choice VIP Preview tickets are allowed to attend Art Basel the day before it opens, giving them extra time to peruse the art and look around without a crowd. VIP ticket holders are also given exclusive access to the private VIP lounge, where the sponsoring brands of Art Basel present select art collaborations and products in their sections.

Art Basel And UBS Global Art Market Report

UBS has an extended history supporting contemporary art and artists, which is why it has partnered with Art Basel for over 26 years. Through its partnership with Art Basel, UBS co-publishes the "Art Basel and UBS Global Art Market Report," an annual global art market analysis that highlights the most important developments in the art world within the last year. This report is an independent and objective study that factors in gallery business, online sales, art fairs, and more to provide an unbiased look at the global art market.

ON-SITE TALKS
Art Basel features more than just artwork at its Miami Beach fair. The Conversations program presents dialogues between prominent

figures in the international art world. The Conversations program features artist talks, panels, and conversations between cultural players such as artists, curators, art lawyers, and critics.

These panel discussions are centered on different topics related to the global contemporary art scene, with each participant giving their own distinct perspective on creating, collecting, and exhibiting art. Conversations range from discussing artists' influencers to how to reach new collectors. These hour-long conversations are meant to stimulate both the audience and the panelists to further explore topics integral to the art scene.

At the 2019 Art Basel fair in Miami Beach, Antwaun Sargent, author of *The New Black Vanguard: Photography between Art and Fashion,* moderated a conversation about contemporary approaches to the portrayal of the Black figure in photography. Joined by leading contemporary photographers Deana Lawson and Paul Mpagi Sepuya and art collector Michael Hoeh, the panel discussed their distinct aesthetics in photography and how they developed.

OFF-SITE ART EXHIBITIONS

Miami Beach is host to a wide variety of world-class art museums, galleries, and private collections that feature modern and contemporary art. Art Basel coordinates special off-site art exhibitions with several of these institutions taking place during their yearly art fair. Many of these off-site art exhibitions take place at renowned museums such as the Institute of Contemporary Art Miami or the Lowe Art Museum. They also take place at alternative art spaces such as Locust Projects or private collections such as the Girl's Club.

One of the cultural institutions that Art Basel coordinates an off-site art exhibition with is The Bass Museum of Art, which hosted the *Better Nights* exhibit by Mickalene Thomas. The New Jersey play, *Put A Little Sugar In My Bowl,* inspired the

installation. The exhibit created an apartment environment that is restructured to reflect the domestic aesthetic of the late 1970s, with faux wood paneling and wallpaper that feature the signature textiles of Mickalene Thomas.

The *Better Nights* installation included both works by Mickalene Thomas, and select works by both emerging and established artists of color. The installation presented different programming arranged by the artist, including live performances and appearances by guest DJs. Installations such as these are common offshoots of the Art Basel Miami Beach art fair that patrons can visit to extend their experience.

Being one of the most prominent art fairs in the world, Art Basel leads several initiatives to further the advancement of art globally. Through its partnership with UBS, Art Basel has provided artists with a vital platform to present their art. With its various galleries, on-site talks, and off-site exhibits, Art Basel is the place to be for collectors and artists alike.

Financial and Market Trends

Key Insights From Art Basel and Tefaf's Art Market Reports

As Art Basel and Tefaf are two of the most recognized art fairs in the world, it is always fascinating to hear their insights on recent trends in the art ecosystem. These two venerable institutions can use their extensive resources to analyze new and continuing long-term trends, which thereby allow all of us to get a better sense of where things are headed.

Reviewing Art Basel's "The Art Market 2020" and Tefaf's "Art Market Report," we can see that there are several key trends related to African-American art and the financial end of art collecting.

ART BASEL'S "THE ART MARKET 2020" REPORT

In "The Art Market 2020 Report," Art Basel explores everything from the financial health of dealers and galleries to how

macroeconomic changes and shaping trends in the art market. UBS, a main sponsor of the report, collected a wealth of data. The overall conclusion was that there was a drop in overall sales by value in 2019, yet the volume of sales overall had reached the highest level in ten years.

Meanwhile, in 2019, the United States remained the largest art market in the world, accounting for 44% of global sales by value. Even with a 5% sales decline year-over-year, the U.S. accounted for its second-highest level of sales in history. The next two largest markets also experienced year-over-year declines. The U.K., which is the second-largest market, had its market decline by 9% to 12.7 billion. Even with that decline, the U.K. still accounted for 20% of the global art market by value. Finally, sales in China fell by double digits (10%), with the country representing 18% of the global art market by value.

In the report, UBS ultimately argues that these year-over-year declines mirror economic developments and trends in wealth creation. Even with these declines, the global art market remains extremely large. $64 billion of art was transacted in 2019 alone. Transaction growth was primarily seen in the gallery and dealer sector (rising over 2% year-over-year), while there were declines in sales at public auctions (17% year-over-year), art fairs (1% year-over-year), and online sales (2% year-over-year).

In terms of *what* is being purchased, newer buyers are purchasing work by female artists, Black artists, and others viewed as being potentially undervalued. This move away from blue-chip, white male artists is being viewed as a positive step in creating more equality within the art ecosystem.

Tefaf's Art Market Report

Tefaf's Art Market Report also reveals some fascinating insights about today's art ecosystem, specifically on the role of patronage. The report's lead sponsor was Bank of America.

In the report, you can see that patronage is a huge component of the art sector. In fact, 78% of respondents in the report's survey stated that they regularly supported charitable and non-commercial arts organizations and initiatives. Around 33% of art patrons offer in-kind or monetary support to the arts on a weekly or monthly basis.

These cash contributions are significant. However, beyond the financial aspects of these contributions, patronage has kept the art market homogenous. Much of this patronage goes to larger organizations, like public art museums. Donating to institutions shapes patrons' collecting practices. Ultimately, Black collectors who want more representation of work by Black artists can help remove obstacles by being strategic about donating work and making financial contributions to art institutions.

Another interesting trend is the rise of the art-secured loan. The asset-based lending market in the U.S. and U.K. has existed for several years, but there are some challenges. Some of these include the stigma regarding financing fine art, vulnerabilities tied with changes in market conditions, the lack of awareness among collectors, dealers, and advisors, and that some collectors don't want to surrender their work for the duration of the loan. While these challenges exist, art-secured loans can be a compelling option for collectors in the art ecosystem.

WATCH THESE TRENDS
These are just some trends identified in both Art Basel's "The Art Market 2020" Report and Tefaf's "Art Market Report." While trends come and go, these trends are worth watching, especially as we are living through disruptive and challenging times. Whether you are an artist, collector, or hold some other role in the art ecosystem, we encourage you to pay close attention.

Chapter 6

Art Schools and
Artists Residencies

Art Schools and Artists Residencies
Are Perfect to Find New Artists

Art collecting can be a very involved endeavor. For collectors who are enamored by the electric feel of new, interesting art, nothing beats the thrill of finding a fresh, talented artist. Apart from the rare opportunity to find a real gem that may become valuable, collectors also get to support a young artist early in their career, just when they need it the most. BFA and MFA programs provide just the perfect opportunity for collectors to find young artists who are experimenting with their medium.

WHY BFA AND MFA PROGRAMS ARE A
GREAT PLACE TO SEARCH FOR NEW ARTISTS

Beckoning with the promise of close tutoring by accomplished faculty members who are often celebrated artists themselves, BFA and MFA programs attract some of the best talent from around the world. As a result, these programs end up being a proven ground for very talented artists, and they can be great for collectors who want to get an early head start on a valuable connection with an artist.

As recent trends show, many of the serious talents of the 20th and 21st centuries were shaped in large part by art schools. Some of them, like the irrepressibly talented Kehinde Wiley, shot to popularity at a very young age, while he was fresh out of school.

Although, since these artists are still developing, there's always the risk that they will find their interests elsewhere in the arts, through curating, teaching or admin, instead of painting, sculpting or photography. But again, there's a decent tradeoff in that a collector might get to acquire a rare painting from a talented individual. I profile Khari Turner later in this chapter, a first-year student at Columbia University's Masters in Fine Arts program.

PRESTIGIOUS BFA AND MFA PROGRAMS
THAT ARE WORTH CHECKING OUT

There are certain art schools attractive to new artists. Due to their prestigious record of alumni and accomplished faculty members, some of these schools are a great place to start when searching for fresh talent. They include:

Yale University School of Art, New Haven

Recognized as the first professional art school in the US, the Yale University School of Art is also one of the highest ranked in the country.

❖ **Notable alumni**—Stanley Whitney, Titus Kaphar, Jennifer Packer, Howardena Pindell

Columbia School of the Arts, New York City

The Columbia School of the Arts' prestigious fine arts program is one of the foremost in the US. With its strategic location in New York City, it is also a great magnet to special talent.

❖ **Notable alumni**—Derrick Adams
❖ **Notable faculty members (previous)**—Sanford Biggers, Kara Walker

School of the Art Institute, Chicago

The School of the Art Institute has one of the largest art programs in the US. The art school is also affiliated with the Art Institute Chicago, one of the foremost art museums in the country.

❖ **Notable alumni**—Sanford Biggers, Eileen Abdul-Rashid, Gertrude Abercrombie, Jack Beal
❖ **Notable faculty members**—Glen Ligon

Rhode Island School of Design, Providence

The Rhode Island School of Design is one of the most celebrated fine art schools in the US.

❖ **Notable alumni**—Kara Walker, Julie Mehretu

California Institute of the Arts, Santa Clarita

The California Institute of the Arts is another great place to find incredibly talented new artists.

❖ **Notable alumni**—Mark Bradford

The School of Visual Arts, New York City

Also located in the heart of US art, New York City, the School of Visual Arts is home to very talented new artists.
- ❖ **Notable alumni**—Lorna Simpson

Virginia Commonwealth School of the Arts, Richmond

The Virginia Commonwealth art school is recognized as the first public arts school in the country.
- ❖ **Notable alumni**—Torkwase Dyson

Pratt Institute, New York City

Pratt Institute has one of the most highly-ranked art programs in the US and has helped launch numerous high-profile artists.
- ❖ **Notable alumni**—Jacob Lawrence, Derrick Adams

How to see these raw gems

There are many ways to come into contact with new and exciting painters at these art schools. These include:
- ❖ **Seasonal shows**: Many of these art schools host art shows one or more times a year. These shows are a perfect opportunity to peruse pieces from unknown artists with the imaginative freedom anonymity provides.
- ❖ **Open studios**: Open studios are a wonderful way to gain some insight into the personal side and motivations of an artist. With emerging artists especially, it can be a unique opportunity to achieve a deep understanding of their art and the value hidden within.
- ❖ **Online presence**: In the 21st century, art collecting is evolving, and these days online channels can be a great for

finding artists. Instagram, Pinterest, and a host of other platforms are very good for viewing some of the relaxed work that new artists do and can also be perfect for building a relationship with them.

❖ **Thesis shows:** Thesis shows feature work created by artists as part of their graduating requirements. Since you'll be witnessing the culmination of an artistic journey, these shows can be quite the visual feast.

Artist Residencies are another way to discover emerging talent. These programs range from a week to a year. Two of the most interesting residency programs were created by Kehinde Wiley and Titus Kaphar, called Black Rock Senegal and NXTHVN respectively. I profile Alisa Sikelianos-Carter later in this chapter, an artist in the 2020 class at NXTHVN.

Khari Turner

MASTERS IN FINE ART STUDENT
Khari Turner on Columbia University's Elite Art Program, Building Relationships, and Identifying as a Black Artist

Khari Turner attributes his rising success to the founding principles of his work: energy, composition, and mark-making.

The 29-year-old Wisconsin native is a first-year painting MFA at Columbia University, home to one of the most prestigious Master of Fine Arts programs in the country. He's made a name for himself by acknowledging the pain of the Black community, without overtly displaying their challenges, to represent the strength of Black lives. Nuanced and subtle, yet striking and powerful, his work sheds light on the collective struggles of his community.

Examine his work, and you'll notice the overarching impact: close-up portraiture, rife with detail, yet marked by a lack of specificity. Only the nose and lips are visible on Khari's

subjects—a deliberate move meant to reinforce the vastness of Black culture, for the artist, in his words, seeks to showcase injustice as an image, transform it into a concept, and simultaneously work on the ground to drive change.

One thing is certain: Khari's enrollment in the Columbia University painting program led to a major shift in his work. While completing his BFA at Tennessee's Austin Peay State University, the young artist was still setting out to find his place. In his words, "the term 'Black' before artist felt like a pigeon-hole"—but he told me that this is no longer the case today. His time at Columbia has cemented his artistic identity in a way that resonates with his work being an expression of Black pride.

There was something about his new alma mater that Khari found alluring. While interviewing with the art department, there was a marked sincerity among the students. They were upfront about the program's difficulties—including those directly linked to the school—yet they urged him to enroll. The artist believes in his energy for creating, as well as in his love of painting and community engagement. This made him an appealing candidate to interviewers, even though, he tells me, he "never shut up" during the interview.

But here he is—a talented, introspective MFA candidate with a hyperawareness of his subject. This past year, Khari has been collaborating with Columbia's justice department. They recently launched an online exhibition featuring the works of incarcerated and formerly incarcerated artists, working closely with several facilities so inmates and those who have since reentered society can show the world their pain and aspirations. It's an exciting initiative undertaken by an artist still remarkably early in his career.

For the time being, Khari will continue to embrace his organic development. He hopes to build relationships in particular with Black collectors; since his work examines Black lives, he finds it especially important that his community collect his art and is mindful of keeping his prices accessible to

the majority of the people he hopes to serve. And ultimately, although artmaking itself is solitary, he calls having others experience his work as a "gift."

This is because genuine engagement is vital to Khari. So too is treating other people—all people—like the human beings they are. And that is precisely what the artist hopes to reveal in his work.

Alisa Sikelianos-Carter

ARTIST RESIDENCIES

Alisa Sikelianos-Carter spent her early years drawing, taking part in art clubs, and exploring the nuances of printmaking. It wasn't until she was in her 30s, though, that she committed to pursuing a career in the arts. She tells me she didn't know it was a viable option until then. She thought that maybe she'd become a social worker, or perhaps a nutritionist, or even an art therapist instead. Then she gave herself permission to do what she wanted.

The artist splits time between Upstate New York, having earned her bachelor's and master's degree from SUNY—Albany, and New Haven, Connecticut, where she received a NXTHVN fellowship from the renowned nonprofit launched by Titus Kaphar, alongside co-founders Jason Price and Jonathan Brand. This quiet setting has played a key role in Alisa's experiences as a Black artist; it's also given her time and space to think, and she's found solace and inspiration in the intermittent interactions she's had. There is beauty amidst all the quiet.

NAVIGATING MICROAGGRESSIONS AS A BLACK ARTIST

At 20, Alisa gave birth to a daughter. When she returned to school, she discloses that she felt overwhelmed by an overt sense of racism. Often, the artist overheard her peers making stark generalizations about the "Black aesthetic," or the "ways Black people talked." She expressed her frustration when

Michael Brown was killed, and others' responses—the careless generalizations some students made—enraged her.

Still, Alisa wanted to make an impact. At the time, she didn't have any Black professors, and there was only one other Black student in the art program. Determined to synthesize her experiences into her art, she considered her surroundings and focused on social justice issues. She can recall, in an early version of her artist statement, writing about "violence against Black bodies," and having a white professor—a man in his 70s—try to convince her to adjust the language. The artist remembers how he questioned her motivations, urging her to pivot her focus and explore a more comfortable concept.

These micro-aggressions, Alisa explains, were integral to shaping her early artwork. Our conversation brings her back to those early classes as an undergraduate; she can recall presentations where her instructors would show Black objects—Black chickens, even—and how her peers were horrified by the images. And so, she imbued her art with the notion of Blackness, of otherness, in contemporary society. In her current artist's statement, she writes:

> "I want to live in a world in which every micro-aggression, attack on humanity, and doubt of divinity aimed at Black people is destroyed by future-sent deities. These GodX are developed and adorned by magnificent cornrows, dreadlocks, and twists. The hairstyles act as armor and weapon, protecting and repelling wearers from white supremacy and misogyny. These are the beings I create."

This theme of otherness—of surviving in an environment where subjects must protect themselves from their surroundings—is paramount to Alisa's acclaim. The Black hairstyles mentioned in her artist's statement, viewers will find, are a significant emblem in her work, particularly the *Crowns* series.

The visionary has found that visually, some interpret the hair as a monster of sorts; they worry it might attack at any second, but it won't, and thus her gorgeous pieces present a unique take on what it means to feel threatened by Blackness.

EXPLORING WHY BLACK COLLECTORS
SHOULD COLLECT BLACK ART

In conversation, Alisa describes the empowering nature of representing Blackness in a figurative style. There's a sense of soul involved, and the artist has thought about what it means for Black collectors to own her work. Already, she has sold several pieces from the *Crowns* series—some of them to white buyers too—and has contemplated what that means. Even though she appreciates all her supporters, she tells me that sometimes when she's traded with Black artists specifically. "I've definitely traded pieces with Black artists and Black folks," she explains. "It's really important to me that [my art] is in [their] home and that [they] get to look at it every day...it is very special to me when Black people get to have [my art]."

Her NXTHVN residency has been invaluable in introducing Alisa to other artists and collectors of color. She heard of the fellowship through a friend who knew co-founder Titus Kaphar and was thrilled to be admitted. Though she had other residencies lined up, she graciously deferred and dived head-first into the intentionality of NXTHVN, which is a space that celebrates artists of color in a unique and profoundly. The program is composed mostly but not exclusively of artists of color, and there's a sense of power in that.

Unparalleled Access:
Connecting with Artists Mid-Residency

There's something to be said for connecting with emerging artists during a residency. Collectors might email the artist

in question, or attend one of their exhibitions, and see if they can meet with them, even for just a short time. NXTHVN is no exception. Alisa appreciates the culture of community within the close-knit fellowship program, where, rather than squirreling away connections, fellows share resources and unwaveringly support each other's work.

At NXTHVN, the artist is often in her studio, and people in the neighborhood would often ring the doorbell just to visit. The NXTHVN space is open and inviting, further proof of how residencies offer an intimate view of artists early in their careers. Alisa tells me she welcomes studio visits and encourages collectors to email her at any time with questions or inquiries, however impromptu or unplanned. Collectors can find artists at residencies like NXTHVN and get a different perspective on what work is being produced. Alisa Sikelianos-Carter also has completed residencies at The Millay Colony for the Arts, Vermont Studio Center, The Wassaic Project, and Yaddo.

Chapter 7

Art Advisors and Artist Liaisons

I f you've been around the scene long enough, don't worry about meeting an art advisor or artist liaison; they'll find you. In a market that is often illiquid and that leaves many outstanding pieces of art undiscovered, artist liaisons and art advisors play an important role.

Essentially, artist liaisons connect talented artists with passionate collectors. They use their experience, refined taste, and knowledge of potential collectors to play the role of matchmaker.

Art liaisons primarily work with artists. In this role, they help artists get fair compensation and share their work with the rest of the world. As for collectors, art liaisons can introduce collectors to artists and pieces of work that they may not normally have encountered without them. That being said, the crux of their role in helping spread the word about artists' work and helping them obtain just compensation.

While artist liaisons play the important role of matchmaker in the art world, they aren't alone in this. art advisors work closely with collectors to find compelling art while getting the most value out of their purchases. After all, the art market is that—a market. Advisors have a deep understanding of the

art market and use that knowledge to help clients make their purchases accordingly. Whether clients are purchasing a piece of art for its aesthetic quality alone, for a financial return, or both, art advisors can help clients save time. In this section, I profile two industry veterans with almost three decades of experience between them: Anwarii Musa of Artmatic and Alaina Simone of Alaina Simone, Inc.

Alaina Simone

In the world of art, there are many stellar artists and passionate collectors who want to display these magnificent works. But all too often, these two groups find it difficult to connect. Matchmaking can be a real challenge, with artists and collectors wanting to make a transaction, yet being unable to do so.

That being said, artist liaisons like Alaina Simone, founder of Alaina Simone Inc, can connect these two parties. Having worked at companies like GM and Nieman Marcus earlier in her career, Alaina eventually transitioned into an exhilarating career in the art world. Under the guidance of mentors and creators like Frank Bowling and Allie McGhee, she has become an artist liaison worth watching. Her work with Black artists and collectors is especially notable, as she makes it a point to work with Black collectors collecting work from Black artists.

OFFERING IMMENSE VALUE TO BOTH ARTISTS AND COLLECTORS

Being an artist liaison, Simone's primary focus is on the artists. She meets with countless artists, taking a close eye to their work. Not only does she want to understand the aesthetic appeal of a particular piece of work, she wants to get a sense of whether the work is a great fit for a particular collector.

Her eye for art is extraordinary. To take just one example, Simone has closely followed the lengthy career of painter Ed Clark, highlighted in Chapter 2.

"As a master painter, Clark pushed the boundaries," Alaina said. "Sure, there are works where he experimented like most artists as they should, but he was pretty consistent. Clark's paintings are extraordinarily sexual, and there is a rhythm to them and movement along with his approach to color that is unparalleled."

Alaina primarily meets collectors through referrals from artists and friends. Because of this, she has to immerse herself within the art world and is always on the lookout to discover new artists and collectors. Any conversation with an artist or friend can lead to future business. But beyond identifying potential collectors, Alaina tries to get inside of their heads. Her goal is to find pieces of art that resonate with her collectors, whether they want to keep a piece for years or are looking for a healthy financial return on their purchase.

When Alaina identifies an artist's work that may be well-suited to a collector, she tries to create the most value for both the collector in question and for the artist whose work is under consideration. She tries to be fair to both sides and create a "win-win" situation. In her field, Alaina has an outstanding track record, with the majority of the art she has sold in the past five years appreciating by 30% or more. But still she laments, "Art is meant to be shown and appreciated for its cultural value, not merely its financial value."

Pursuing a Larger Mission

Alaina's financial track record is impressive. But beyond the pure numbers, she has a larger mission: for Black collectors to collect Black art.

The stark reality, however, is that we are still in the early stages of reaching this goal. Black and brown artists have only begun being represented by blue-chip galleries in the past five to ten years. In fact, Alaina only saw her first auction results for an African-American artist in 2008. Still, this novelty presents many opportunities for Simone to promote Black and Brown artists in the art world.

Whether she is working with a Black artist or any other, Alaina tries to ensure that their work matures in the market before it appears at auction. What that means is she wants her artists in the hands of collectors not flippers. Along with this, she makes collectors sign contracts where they are prohibited from selling for a period and need to give the artist a percentage of any secondary market sales. Because she has seen Black and Brown artists' work being discounted for so long, she does everything in her power to ensure that artists are being fairly compensated.

In just one example, the art world took notice when Christie's held its 2008 auction that featured African American artworks by modern masters such as Jacob Lawrence, Romare Bearden and Norman Lewis along side contemporary artists like Carrie Mae Weems. According to Alaina, "this auction made the market, but I felt discouraged because certain artists, collectors, and dealers wouldn't be the benefactors of this rise in interests." Alaina notices these nuances and, once again, works to ensure that both artists and collectors get the most value from a transaction.

The bottom line, however, is that Alaina has repeatedly seen the sheer joy and impact of Black collectors collecting Black art. For instance, she met a collector who mentioned he had purchased a Romare Bearden work for around $750. Then, around 30 years later, he sold it for approximately $250,000. Not only did the work substantially appreciate, allowing him to afford his children's college tuition, but the painting became a mainstay throughout his family's life. There was a genuine joy to have his children grow up with a Romare Bearden work in the home. The pleasure it brought to his family was immeasurable.

This idea of promoting and growing Black wealth and appreciation for culture cannot be overstated. Alaina has even witnessed this effect in her own life. Her mother grew up in the Jim Crow South, where she couldn't enter a museum or library. As a result, her family had to take drastic action to learn about Black art and culture. In today's world, however,

connecting Black artists and collectors is a significant step in accomplishing this overall mission.

"Children need to grow up with examples of Black excellence in this country and the diaspora at large," she said. "This is especially because of the negative stereotypes that we see in the media."

A One-of-a-Kind Artist Liaison

Alaina is a talented, knowledgeable, and extremely driven individual passionate about her craft. She lives and breathes art, all while carrying out her mission of connecting Black artists with Black collectors. It's safe to say that Alaina will continue to do great things. She is an artist liaison that you should definitely track in the months and years to come.

Anwarii Musa

An Art Advisor Who Creates Immense Value for Art Collectors

The art world has many actors, from the artists themselves to the auctioneers who slam the gavel on a major purchase. That being said, art advisors play a vital role within the art ecosystem.

At a basic level, art advisors work with art collectors to help them accomplish their goals. This can include everything from helping collectors find pieces that deeply resonate with them to finding art that can generate a satisfactory financial return.

While there are plenty of art advisors in the world, I want to focus on one in particular. Anwarii Musa is an art advisor who has dedicated his professional life to the art business. Starting as an intern with Sotheby's in 2008, Anwarii, often known by his last name, worked at the renowned auction house for five years before starting his own company, Artmatic, in 2014.

Along with helping his collectors accomplish their objectives, he is focused on connecting Black artists with Black

collectors. Ultimately, this is a higher calling for him and one that helps bring Black collectors into the larger conversations happening within the art world.

FOLLOWING HIS PASSION AND MAKING A DIF-
FERENCE IN THE ART ECOSYSTEM

With his experiences at Sotheby's and as an entrepreneur, Anwarii is a rising star in the art ecosystem. He has developed great relationships with collectors, galleries, and artists alike, allowing him to quickly provide value to his clients.

Like many other types of service-based businesses, Anwarii gets many of his new clients from referrals. His current clients' friends, business associates, and others recommend him due to his expertise, work ethic, and stellar service. Having built a great reputation in such a brief period, he can rely on referral traffic to find new clients.

Upon signing a new client, Anwarii begins by sitting down with them and exploring their preferences. He also educates the clients about different artists in the marketplace, including their backgrounds and the mediums that they use. While it depends on the client's preferences, the general idea is to share his knowledge and understand the client's needs and partialities. Doing this, he can provide the most value possible to the client.

When Anwarii understands his clients' wants and objectives, he tries to match them with outstanding pieces of artwork at a fair price. He inspects the artist's history and how their work has grown over the past number of years. For instance, he looks at the education of the artist, how their work has evolved, and even the different materials or paint used to create their work.

One tangible example is the renowned artist Kehinde Wiley. Looking at his earlier work, Anwarii noticed pencil lines and other extraneous markings and could tell that Kehinde was improving the quality of his work. Now, he and other art

connoisseurs can see that Wiley has truly perfected his craft. These factors, along with macro factors like demand in the art market, comprise the price for a certain work.

This is part of the reason why Anwarii is also a passionate scholar of art history. He studies everything from the old masters and American paintings to Greek mythology. A significant amount of thought goes into recommending a work for a client, so he wants to be as informed and educated as possible in order to save his clients time.

A HIGHER MISSION

Anwarii is a talented and driven art advisor who provides immense value to his clients. Yet he goes one step further. He believes that it is important for Black collectors to collect Black art. For him, it comes down to Black collectors becoming part of the conversation.

"I think for a long time, Black collectors weren't a part of the conversation. This is because most artists that are Black and very successful were not collected by Black collectors. It occurred for many, many years. But from my experience and work with my clients, I believe that the conversation is shifting."

One of the great examples of this shifting conversation involves the artist Kerry James Marshall. As mentioned before, a year and a half ago Marshall's *Past Times* sold for $21 million at Sotheby's, making it the largest sum sold for the work of a living African-American artist. That said, Marshall's work wasn't always as widely celebrated as it is now. When Anwarii was at Sotheby's, he doesn't recall seeing any of Marshall's work. Prior to *Past Times*, the most expensive piece that Marshall sold was $1 million.

Thus, even though Marshall was already making masterful work, it took a catalyst to shine the light on his unmistakable talent. His work being sold for such an eye-popping number was that catalyst. Not only was the price stunning, but so was the buyer: Sean Combs, also known as P Diddy.

When the sale occurred, Anwarii was physically in the room. As he recalled, there was a distinct feeling in the air. "If I could describe the room in one word, I would say *accomplishment*. I felt like we accomplished something that night as a collective, as an art community, as a Black collective. You felt it that night. It was a really good and satisfying moment in the art community."

While the *Past Times* purchase was a monumental event for Black artists and Black collectors, Anwarii believes that there is still much more work to do. There are plenty of talented Black artists beyond Marshall. And, working with art advisors like Anwarii, Black collectors can accelerate the positive effect that Black art has on the entire African-American community.

Making Waves in the Art World

In sum, Anwarii's work as an art advisor speaks for itself. He uses his knowledge, experience, and passion for art to help art collectors accomplish their goals. He treats his clients like family and works tirelessly to make sure they have a great experience.

But beyond that, Anwarii connects Black artists with Black collectors. In doing so, he helps advance the conversation and ensure that African-American art is celebrated for years to come.

Chapter 8

Dominic Chambers

#TheChambersCollection When artists collects the work of their peers

There are plenty of important roles to go around in the art world, ranging from the art liaisons who help connect artists and collectors to art advisors who help collectors accomplish their financial and non-financial goals. And there are also the artists themselves, who put their hearts and souls into their work and share it with the rest of the world.

That said, some unique individuals in the art world wear multiple hats. They not only create their own work, but collect other artists' work and introduce them to each other. These special individuals create a tremendous amount of value within the art community. This is especially true if they began doing this earlier on in their careers.

One of those special individuals is Dominic Chambers. Along with being a talented artist, Dom is an outstanding art collector. (I met Dominic the summer of 2019 and started visiting his studio in New Haven while I was there completing a workshop at Yale University.) Even more surprising: he isn't even 30 yet. Dominic is intelligent, passionate about art, and

works hard to perfect his craft. It's clear that he will make waves in the art ecosystem for years to come.

A Long-Standing Passion for Art

Even though he is not yet 30 years old, Dominic's professional life has centered on art. Originally from St. Louis, he received his BFA from the Milwaukee Institute of Art and Design. From there, he finished his MFA from the Yale University School of Art.

Having graduated from these two renowned schools, Dominic entered professional life with in-depth knowledge of art history and technical skill development. His art history studies created a sound foundation for thinking about and solving painting problems. Like other artists and art collectors, Dominic developed a unique vision of what makes both good and *great* artists. For him, it goes beyond the simple appearance of a piece of work. "I am not necessarily interested in artists who are committed to making things that simply look good," he said. "Instead, I am interested in an artist's intellectual investigations. Bad artists, to me, are artists that are solely interested in satisfying their egos. They are creating works that require no degree of critical thinking or examination."

In Dominic's mind, a good artist can make interesting works. They can hold an audience's attention for a certain period of mind. The *great* artists, however, can make interesting art *while* being conscious about their subjectivity and relationship with the world around them. Great art isn't just about the aesthetics; it is a highly critical intellectual activity. Dominic applies this attitude to making his own art and to collecting it. He traces his collecting inspiration to visiting a collector's house and watching an *Art21* episode where Rashid Johnson trades artwork with Angel Ortoro. He loved the fact that collectors developed their own independent relationships with their art. Following in their footsteps seemed like a brilliant idea.

From there, he dipped his toes in the collecting world by purchasing several of his friends' artwork while at grad school. He continues to collect the work of friends or artists who fascinate him. Some of these people include Shikeith, Ana Benaroya, Vaughn Spann, Mike Shultis, Ye Quinn, and others. However, unlike so many other collectors, Dominic doesn't intend to sell his collection. To him, having these artists' works in his life contains a deeper meaning than the paint on the canvas. They are symbols of people who Dominic was privileged to meet throughout his young life.

Mostly, Dominic focuses on paintings and photography. He also has three sculptures, but collects these sparingly due to space constraints. He mostly owns figurative works. The largest number of artworks from a single artist in Dominic's collection are all abstract pieces by Alteronce Gumby, an artist he especially admires.

Dominic has excellent taste. But beyond aesthetics, he makes a point of acquiring work by Black artists. Not only does he think it's important to highlight the excellence and beauty of African-American community and culture, he also wants to underscore the contributions that Black artists are making to the art historical canon. Black artists, says Dominic, have been historically undermined for far too long. That being said, the tide is shifting, with more Black collectors collecting work from Black artists. With Black children growing up in spaces with work from Black artists, he believes that momentum will only increase.

For those who are thinking of starting their own art collections, Dominic recommends that they first follow their passion: "I would advise [new collectors] to purchase things that they enjoy first and foremost, within a considerable price range. Once you develop good footing and develop a good eye for artworks, collect the works of artists they want to follow and whose career they are invested in. Don't allow market trends

or temporary spotlights on a given artist to drive your desire for who to collect. That's not necessarily the most effective and meaningful way to collect in my opinion."

Especially for someone so young, Dominic's eye for talent and passion for collecting is a joy to see; he has a long career ahead of him. I can't wait to see what happens next.

Chapter 9

Black art arrives at the Auctions

Swann Gallery Auctions

Swann Galleries: A Black Art Collector's Dream

Swann galleries is an auction house founded in 1941 that specializes in rare books and African American Fine Art. Near Madison Square Park in Manhattan, this auction house has been a fixture as one of the oldest specialty auction houses in New York. Although Swann Galleries conducts over 40 sales a year, there is one auction in particular that should be discussed, as it was the highest selling auction ever dedicated to African American artists.

When Swann Galleries held its biannual African American Fine Art sale on April 5, 2018, pieces by Beauford Delaney, Norman Lewis, and other artists surpassed the high estimates. Almost twelve artists set new benchmarks, and Lewis rose to the top with an untitled abstract piece that sold for the second-highest price at an auction for work by the artist. The sales for the auction were $4,509,540, a record for Swann for a sale in the African American Fine Art department, and the entire auction house. This incredible number shows the growing demand for modern and contemporary works by African American artists.

The curated auction that night had 160 works from auction debuts to rediscoveries and masterpieces from some of the most influential movements of the 20th century. From the nine lots that were over $100,000 four were new artist records and two were the second-highest priced works by the artists in question. The *Untitled* abstract painting by Lewis sold for $725,000, almost triple the high estimate of $250,000. Another abstract cityscape sold for a record $557,000 for Beauford Delaney, more than double the $250,000 high estimate. This piece is an oil painting exhibiting the streets of Greenwich Village in Manhattan.

Meanwhile, a life-size coal drawing by Charles White called *O Freedom* easily sold past its $300,000 high estimate, resulting in a record $509,000 for the artist. The piece hadn't been seen in public for over 60 years, yet still generated interest. One of the most fascinating pieces in the sale was a rediscovered work from Jacob Lawrence's profound series, *Struggle...From the History of the American People.* As one of the five pieces missing from the series intended to document the history of the United States from 1776 to 1817, *19. Tension on the High Seas* was purchased at over four times its high estimate.

Director Nigel Freeman has expanded the African American auction market through his sales at Swann Galleries dating back to 2007. Over the past couple of decades, the size and volume of sales for African American artists has steadily grown in the modern and contemporary art market. Besides established artists such as Norman Lewis, Elizabeth Catlett, and Robert Duncanson, artists such as Faith Ringgold and Frank Bowling are coveted. The contemporary art market has grown significantly in the past few decades and is projected to continue growing.

Sotheby's

How to Make Money as an Art Collector
Buying and Selling Art from Sotheby's

If you are an avid art collector, you may have an array of extraordinary objects in your collection, from fine jewelry to contemporary paintings. Although these pieces are invaluable, they also can make you a considerable profit. With this in mind, Sotheby's is one of the two premier destinations for art collectors looking to buy or sell exceptional pieces. Sotheby's is a British-founded American corporation with headquarters in New York City. As one of the world's major brokers of fine and decorative art, jewelry, real estate and collectibles, Sotheby's is trusted by many collectors from all over the world.

BUYING OR SELLING WITH AN AUCTION HOUSE

When choosing to buy or sell with an auction house, there are a few things to keep in mind:

- ❖ They will most likely take a 20 to 30 percent commission from the sale.
- ❖ You may negotiate their auction house fee to a number that fits your lifestyle.
- ❖ Make sure the piece is listed at a fair price so you do not intimidate potential buyers. You need to be comfortable with the price your piece is listed at.
- ❖ Make sure you alert your insurance company and that your policy is current.
- ❖ Confirm transportation to prevent unnecessary damage.
- ❖ Thoroughly read through any contracts and have an attorney review it.

BUYING AND SELLING SUCCESSFULLY WITH SOTHEBY'S

Collectors continuously turn to Sotheby's for the best value for their extraordinary objects, while buyers depend on Sotheby's for the finest objects available. As a multinational corporation with locations in over 70 cities, they are well equipped to assist avid sellers and buyers with any and all requests. Additionally, Sotheby's is experienced in more than 50 different categories of objects ranging from Furniture to Wine to Antiquities and Modern art. Working with them guarantees that you will receive the best offer for your unique object.

BASQUIAT'S RECORD-SHATTERING SALE

The painting, *Untitled,* created by Jean-Michel Basquiat in 1982 sold for $110.5 million at Sotheby's in New York over thirty years later, when the artist had long been dead. This was an auction record for the highest price paid for work by an American artist, and for any work created after 1980. This record-breaking sale price marked an almost $110 million profit for the daughter of two art collectors who had originally purchased the piece for $19,000 in 1984. A Japanese billionaire, Yusaku Maezawa, founder of a Japanese fashion site, bought this incredible piece. Although this sale was one-of-a-kind, there's no telling what the future will hold for record-breaking auctions. There's no guarantee that every painting will sell for millions of dollars, but the lure of the potential financial gain is undeniable. Basquiat's work has increased exponentially, while the others also have steadily increased over the years. Street art has become a lucrative emerging trend that doesn't seem to fade. It has continued to dominate the market when it comes to lots sold.

Christie's

Amy Sherald: The Biggest Emerging Artist at Christie's Art Auction?

Christie's, founded in 1766 by James Christie, is a British auction house known for selling art. Although it was founded in London, Christie's became one of the world's leading auction houses. In his lifetime, Christie was friends with numerous artists and his grounds were known to be the gathering place for collectors, dealers, and all of fashionable society. His knowledge of art was demonstrated through the transactions he handled. After Christie's death, the firm underwent a reorganization into a private company to rival Sotheby's. Soon after that, Christie's began expanding beyond the United Kingdom by opening locations in Tokyo, Rome, Geneva, and New York City. Christie's has been involved in many historic sales, including the sale of *Salvator Mundi,* a Leonardo da Vinci painting that was sold for $450.3 million—the highest price paid for any piece of art ever.

When it comes to auctions, sales prices and estimates are not the only indicator of performance. There is something to be said for an artists' value in the market based on the auction houses that will consign their work. If an artist has secured a spot with an auction house like Christie's, Sotheby's or Phillips, then there is sure to be a major profit. According to the chart below, you can see which of the artists who debuted at these auction houses outperformed their estimate.

Artists like Mark Rothko and Andy Warhol shattered their high estimates with sales millions of dollars over their high estimate; the art of African American artists are seldom on that list of multi-million-dollar sales. Despite this, I'd like to focus on certified African American star Amy Sherald. She made her debut 2019 at Christie's with a portrait that sold for three times the original high estimate. Sherald's *Innocent You, Innocent Me* was the first work by the artist to be offered at a major auction.

Although it was estimated to sell for $80,000-$120,000, the piece reached $350,000, no easy feat.

Sherald is a Baltimore based artist who paints portraits of African Americans she may have seen in public while going about her day. She paints in grayscale to focus on their humanity and uniqueness rather than their race. Her career catapulted shortly after being selected by Michelle Obama to paint her official portrait for the Smithsonian museum. So far, Sherald's career has given us just a taste of what is yet to come. Black contemporary art, especially by Black female contemporary artists, is a category that is thriving. Many of the Black female artists who debuted at Christie's exceeded their estimates, which speaks to the newfound appreciation for Black contemporary art.

Chapter 10

On Collectors

Intellect and Culture: Does Buying Art Really Distinguish You?

Whether you're a new homeowner on a decoration journey or an art enthusiast looking to add to your collection, art is a great way to add personality to our spaces. Although many people decorate their homes with wall décor from retailers like Ikea, HomeGoods, Target, and more, mass-produced art cannot compare to original art found in galleries, fairs, and the studio. In this section, I will explain how one goes about buying original art.

Original art is characterized as a luxury purchase because it sells well in times of economic prosperity and poorly in times of economic distress. It is a discretionary expense that perfectly embodies the essence of luxury. When it comes to purchasing art, price is one of the biggest considerations. Due to its discretionary nature, there's no pressure or need to buy an art piece.

Therefore, many factors come into play. Interest is a huge determining factor; one may want to view the art privately or place it somewhere others can view it. Either way, this majorly affects the type of art that will be purchased. If it is meant for personal viewing, then the piece will immensely impact the buyer, and they must feel a strong connection to the piece

that ultimately compels them to purchase it. If the piece is purchased for the enjoyment of other people, then the piece likely will not speak as much to the buyer, instead solely serving as a status piece. Buying art offers many things to the buyer, including a sense of community, power, cultural superiority, social distinction, with some people even stating that it offers spiritual fulfilment. In the next few chapters I will introduce you to some stories of Black collectors.

Art Collectors

There are no budgetary restrictions where collecting art is concerned. This is because there is no one-size-fits-all approach to collecting—and hobbyists and first-generation collectors, who might be focused on sourcing the works of emerging artists, and highly sophisticated or legacy art connoisseurs, who invest millions into supporting the careers of celebrated artists, can come together and cater to various segments of the art space.

Who are the different types of collectors? There are those who value the artist's experience and reputation above all else, who have earned multiple degrees in art history or curatorial studies, and whose educations run so deep that they add fine art to their collections based on pure knowledge and a deep understanding of the industry. These collectors have the budget to purchase big-name pieces, ensuring the future of already successful artists and claiming their stake in the future of the art world.

Then there are the aesthetically driven collectors, who may well still collect professionally but with a specific visual focus in mind. Others rely more on a more visceral, emotional reaction to the pieces they collect, purchasing pieces on instinct. Both groups are more open to collecting from unknown artists, and helping them in their development, than their fine art collector counterparts. Hobbyist or professional collectors may also move through the art space keeping themes like legacy and cultural preservation in mind.

The price of a piece of art may start as low as $50 and go upwards of $20 million or more. Above all else, art collecting is on a spectrum, and so I invite you to commit to the approach that resonates most with you. I invite you to explore your needs and interests and see where your collecting journey takes you.

Chapter 11

Hill Harper

All his life, Hill Harper has been surrounded by art. Both of his parents were art lovers, who shared their love of the field with him, introducing him to their tastes and to the work that meant the most to them. They taught him how to look at art and cherish art and exposed him to many pieces that would stick with him for a long time. Speaking of one piece in particular, he talks about the significance that it still holds for him and his efforts to figure out where it is today—how he has gone between his mother, his father, his brother, and even a museum, all to locate this piece that he remembers from his childhood. "I'm going to want to track down that painting," he says. This is as solid an emblem for his feelings about art as any other, the deeply personal way that he looks at every piece, the way that he invests in art and holds it dear.

Harper's parents also taught him to break out into the world and seek opportunities to learn from experience. Talking about museums, he seems to look back on them as fondly for the art that would become such a large part of his life as for the adventures that they represented to him. Along with museums, he reveled in trips to the zoo and the aquarium; all the afternoons that he and his brother spent adventuring helped to shape him into the daring and unique person who he is, encouraging him to see the world through his own two eyes and to make himself

comfortable with things that were new and out of the ordinary. For an art collector, this mindset seems not only rational but necessary, contributing substantially to his willingness to face the unknown and to keep his cool in all situations.

Discussing culture, Harper goes on smoothly and confidently, and he relates his own experiences to those of the Black community automatically, clarifying that he views himself in terms of his culture and his heritage. He says, "I think a lot of Black folks understand that many of us have the ability to be comfortable on the corner of the stoop and at the White House, and never feel uncomfortable in any range of those experiences. It speaks to non-judgment and placing no higher value on any type of experience from going to the most lavish of places to the places that are deep and challenging."

As quick as Harper is to connect his adventurous and bold nature to his cultural identity, though, he is also quick to recognize the role it has played in his growth and development as an art collector. He sees that because of his openness to new ideas and his comfort with the potentially uncomfortable: he can navigate all the pitfalls of the art world, never falling prey to the elitism and never paying more mind to people's upbringing than to their creativity and their style, which is after all the real value of the art that they are producing.

Harper started collecting art unassumingly, purchasing pieces of art that he admired. Tipped off by a friend of his while he was a graduate student at Harvard, he looked at an Earnest Crichlow, a New York artist about whom he knew little. Despite the heavy student debt that he was under—a six-figure sum by the time he had earned his degree—he found the cash to get the piece, going off little more than his own gut feeling that it was something, that it was special, and that he wanted to own it. Since then, he has studied a good deal about Crichlow, but back then, he was making a decision based on his own assessment of the art, its value independent of what anyone

else thought. And even long before Harper owned a Crichlow, he had learned the joys of collecting art by assembling album covers on his bedroom wall—going off for the pleasure that he derived from each piece of art.

This straightforward, honest approach to art is even more evident when Harper talks about the street artist Jabolo. He describes his first encounter with Jabolo endearingly, saying that "He was a homeless cat down in the village and he was always on the street with his art. When he and I talked, he said he was homeless. I'm not sure if he was homeless or not. But he did this beautiful work and I bought it. I may have bought that during college or right around the same time. And another buddy of mine had bought Jabolo completely separately because he was downtown New York on the street all the time, and it was always found materials and he used magic markers." Such a quaint story, Harper tells in tones of excitement, thrilled to talk about an artist whom *he* met and whom he discovered. He concludes by saying, "I love, love my Jabolo."

When asked how he chooses the artists he collects, Harper speaks immediately *about* the artists as people, not their styles, and not the "school" that they come from. He says that he appreciates meeting the artists whose art he adds to his collection, forming a relationship with them if possible, and learning to appreciate them and their unique identities. He refers to one artist, Alvin Clayton, whose work he first purchased and collected shortly after he had relocated to Los Angeles to pursue his acting career. Following up immediately, he can rattle off Clayton's current whereabouts, as in "He is not doing much art anymore, but he opened up this great soul food restaurant out in Connecticut," suggesting how you would talk about an old friend, someone you chat with regularly.

Of other artist he collects, Kehinde Wiley, Nathaniel Mary Quinn, Mickalene Thomas, Yoyo Lander, Nate Lewis, Carrie Mae Weems, Debra Roberts, Ebony Patterson, Derrick Adams, Kennedy

Yanko, Titus Kaphar, Tiff Massey, Tylonn Sawyer—rattling off the names of major luminaries, living legends, but he talks about them as people, not as names on a billboard at a gallery.

Speaking about a documentary he has been working to produce, he refers to the artist Thornton Dial, known for making extensively using assembled materials, and when he refers to a term common among certain art critics, "found materials," the seriousness of his opinions as a collector shines forth. He holds definitive opinions about the artists whom he admires how, often unfairly, art circles have sometimes discussed them. Once again, Harper's boldness and courage are on full display: he sees the appropriation, the misunderstanding, the abuse, and he connects it back in no uncertain terms to the reality of slavery and everything that comes with it.

When Harper moves into a more direct discussion of the art that slaves and their descendants created, he becomes even more lucid. He explains how the art world has tried to "devalue something rather than just judging it for the piece of work as it is" by separating the works from all other art, labeling it either "found art" or "folk art," as if it were in a category other than fine art. As a collector, he is doing critical work to push back against this assault, the act of categorizing art properly—as art—his defense.

As a collector, Harper says that he continues to attend art fairs of all sizes, not only the largest ones. Despite the clout that his name carries in the art world, he speaks lovingly about a Brooklyn-based art fair, The Other Art Fair, where admission is five dollars and the artists present their own pieces at a booth. This is Harper *in his element*, artists known and unknown mingling and sharing their opinions of the community, unabashed in their discussion of history, style, and the creative process. He admits that because of his professional reputation; he has access to opportunities and events that others may not, but when conversation returns to the undiscovered and the off-the-beaten-path, that is when his energy spikes. He is, if nothing

else, tenacious in his appreciation as an act of discovery, trying hard to notice art that no one else has yet.

Recalling a circa-2000 Banksy show that he was set to attend in LA, Harper says, "I had heard about this artist that people were talking about named Banksy. So I'm like fifth or six in line, and then the line gets long, I mean it goes down the street around the corner, but I'm like fifth or sixth and we're waiting. I think I waited about two hours, whatever because I got there early. And they open, and I walk in and it's incredible." When he finally got into the warehouse, however, the piece he wanted—a now-famous image of a girl holding a balloon—was already sold to a VIP before the public event had even started. The night after the Banksy show, Harper mentions, he had attended a show for Shepard Fairey, where he met the artist and ultimately built a friendship with him.

Harper also relates how he introduced Shepard Fairey to Obama's first presidential campaign during the 2008 Democratic primary, and although he connects it back to his experience with Banksy, the subtext is clear: for Harper, the personal and the public are one. He is an intensely sincere collector because this is how he thinks, seeing no distinction between the friendships and bonds that he has forged and the work that he is doing to make the art world more moral and more aware, recognizing the value of the artists he collects as artists, not as "folk artists" or "found artists."

Harper also talks about Johnson Publishing, the NAACP, and the Urban League from a place of concern, talking about how these major institutions have encountered difficulties in funding and in planning. It is clear that his mind is on finding solutions in the form of a new generation of leaders. His advice is inspiring, and he is unmistakably optimistic: "Keep that energy going in a way that you started the fire and then let them take it and go with it, and not hold onto it till your dying breath and then it dies with you."

Besides this, Harper was law school classmates with Barack Obama, served on his national finance committee, and had a modest role in pairing the artist who created the "HOPE" posters to the campaign team. As a result, he talks about historical moments, like those with Obama, and more obscure ones, like chance meetings with less-famous artists, in an equally exuberant tone. For Harper, the art that he collects is art, nothing more and nothing less, and he chooses it the same way he chose his first Crichlow, on feeling. As he puts it, "I think that folks should collect exactly what they want and how they want to do it. But I ultimately collect what I'm exposed to and what moves me."

Chapter 12

Anonymous collector

Art Collection Through the Eyes of a Connoisseur—Old Motives and New Measures

Art collecting is often a curious thing. It means different things to most, and collectors often have unique ways of amassing their collections. But for all of them, the motivation usually boils down to the same thing: an interesting love for the contemplative beauty that visual art exudes. Despite this, perhaps the most fundamental principle in art collecting is that there are no rules. Building a collection is mostly emotional, and each collector ends up developing their process in their own unique way.

In this meeting with a Black collector (we'll call him Marcus), who wishes to remain anonymous, an American collector with intercontinental tastes, I explore what it means to be a collector in America and how he starts with guidelines to build his speculative focused assemblage.

Humble beginnings

What makes an art collector? Since collecting is often a time-intensive and expensive endeavor, it's interesting to see how collectors became so enamored with assembling pieces from varying artists.

In addition, collectors often have intriguing patterns to the way they acquire their pieces. Art collectors have wide collections, with statistics indicating that 53% have at least 500 works in their possession. In most of these collections, whether consciously or otherwise, a pattern emerges, which is always interesting to note. This is why one of the most common questions that art collectors answer is why they started collecting.

For many, it started as a way of life. Because of their exposure to art, either through art museums or some personal talent, they grew to prize works from talented individuals.

Hailing from the south, Marcus is a finance professional, who took little more than a passing interest in art from a young age. Unlike most connoisseurs, he never really grew up with art playing a large part in his life. According to him, "Art was not a part of my life growing up, for the most part. Growing up in a city burdened by the history of slavery, life was just day-to-day—but there was art all around me in the form of culture, music and whatnot but—I didn't necessarily register what was happening around me…"

Another interesting point about Marcus is his background. His parents were immigrants in the US, without the benefit of an extensive education. As a result, his childhood was mostly devoid of the impressions that influence many would be collectors. It wasn't until High School that he saw much in the way of fine art, when he joined an art class and made his first trip to the museum.

In his words, "When I got to college, I went to the museum a few other times, but I had this perception that art is for rich people. That was pretty much it. We did not know any Black families that were like, well-to-do—or collected art. So we did not really have any intro [to art]. I knew nothing about all of the great Black artists from the 60s and 70s or any of those periods."

Marcus believes his proper introduction to the art phase came when he took an interest in jazz, especially the old records. Although he was never really a fan of this music, he was exposed to the jazz scene through his dad at a very young age. "My father was a huge jazz fan. He was born in 1928 and when he first came to Harlem, that was like in the late 50s, early 60s, he hung out with a lot of jazz musicians. Sandman Simms from Apollo was his good friend."

This exposure often came against his will, though. "Jazz music was something I did not love too much as a kid, but in my father's car that was the only thing I had the option of listening to…" His father was quite an influence, and this eventually showed later on in his life. According to Marcus, "I lost my dad when I was about 20 years old and in my 20s, I fell deep into jazz music. I spent a lot of time on the jazz scene and just taking in music and learning about that. So that was like one art form. I started getting some records, collecting some records, then I became a collector of records."

From collecting old records and album art, it was a small step from there to buying his first real artwork. As he explains, "I went to a couple folk homes. I saw some nice artwork and I decided that maybe I should have some art. In 2015, my wife and I went to Turkey and while we were at the resort, we went into the gallery and I bought my first real piece of art, I would say. It was a print by a Turkish artist."

MODERN DAY COLLECTOR

Marcus goes about building his collection with a style that some may consider radical. He conducts his research and connects with artists mostly through online media, especially Facebook, Instagram, and Google.

He says "I had recently gotten onto Instagram, I was checking out some artwork, and I discovered the work of a young

artist by the name of Ndidi Emefiele. I just loved the work. I was like, wow, that is really fantastic. At the time, she was at The Slade School of Fine Art, she was a student there, and so I reached out to her via Facebook because she was not actually on Instagram, but her work was on Instagram. We connected. We met in London and I bought my first piece of artwork from her."

"With Instagram, I started to follow a whole bunch of artists based on my research. Then from there I just started to buy other artists that I was finding online. I thought that the work was in my budget and that is how I got started... I just googled art collecting, and I read articles. Whatever I could find on the internet is what I researched."

Eventually, Marcus came around to deciding on a theme for his collection, as most art collectors do. For him, two things were of the utmost importance: investment value and socio-cultural leanings. "I came across some research that mentioned that the work of women artists tends to be valued at a much deeper discount than the work of a male artists," he explained. "Also, the work of Black artists was also at a discount to the overall market." Knowing what he knew about various economic trends and the fact that women were earning more than compared to men, and more women entering the workplace, his gut told him that tastes would be changing.

His idea was that over time these changes would play out in the art world. Essentially, he calculated that since women entered the workplace to earn more money, they will want to see themselves represented in art. Of course, because of the socio-cultural aspect, he decided to focus on artworks from women of color. "I came to the conclusion that if I was looking for value that I should look at Black women artists because that group, if I studied it well, then the collection stood the highest chance of being unique and having a theme. I decided that going forward, I would try to allocate 80 percent of the spend to that group."

Today, Marcus has a wide-ranging collection, including works by female artists such as Deborah Roberts, Somaya Critchlow, and Nike Davies-Okundaye.

For collectors, buying abstract or figurative art is always a big debate. Abstract is known to hold a deeper intellectual value, whereas figurative is easier to digest and understand, even amongst beginners. Like most collectors, he started strictly figuratively. It's more accessible for most people because we see ourselves in the work and you can identify what you are seeing. At the same time, over the last few years Marcus has added some abstract as he's arrived at a deeper understanding of collecting and the history of art. Like most collectors, the more they know, the more their tastes change.

His taste in what he collects is also changing. Marcus started out buying strictly from artists, but now he buys more from galleries, and from artists sometimes. After building relationships with several artists, he is not buying their work directly, because he has developed real friendships with some of them. "They are advocates for me," he says, "in terms of getting work allocated from the gallery which sometimes is tough."

While many people buy at art fairs, Marcus leverages art fairs as a place for information gathering and networking.

Although his collection started as a way to appreciate the beauty of art, nowadays he finds an even stronger purpose in collecting. Having children makes most art collectors consider legacy planning strategies and shapes the way they collect. He says "Now, I have two little girls and so I keep them in mind for my collection as well. Right now, I feel like there is definitely a purpose to the collection because I feel like now I am building it for them."

Chapter 13

Audrey Adams & Lauren Maillian

Like Mother, Like Daughter—Passing On and Building a Love of Art

Audrey and Lauren share more than a mother-daughter bond: they are part of the same proud line of art collecting and cultural preservation.

Audrey grew up around art, learning an appreciation for it when she was still a child. Her father served in the Air Force for thirty years, and all that time, he and his family were traveling around the world, seeing different places and adapting to unfamiliar environments and cultures. Visiting top national museums far away from the United States, Audrey developed her own unique sense for art early on, forming firm opinions about what she liked and what she looked for from one piece to the next.

While the scenery and the names at the bottoms of the art in the galleries changed, there were always certain constants in Audrey's life. Two such constants were the magazines in her family home: *Ebony Magazine* and *Jet Magazine*. Just as she accepted art naturally as a part of her life, she accepted *Ebony* and *Jet* too. In her teenage years, she picked up copies of *Seventeen* and *Mademoiselle*, as many youthful women would,

but *Ebony* and *Jet* were omnipresent. Her mother and father purchased and collected art, and like that, she took the images in the magazines and the portraits—images of people who looked like her—as wholly natural, never as something other.

In the same way, Audrey's daughter Lauren grew up around art, the pieces that Audrey collected adorning every spot on the walls of their New York City home. There were pieces large and small everywhere the eye could see. Immersing herself in dancing at a dance theater in Harlem from the time that she was a young girl, Lauren would dance around the paintings, knowing the names of the artists but too young to be fully aware of the weight that those names carried. Awareness, however, would have been ancillary, and exposure alone ingrained an appreciation for art in Lauren.

As Audrey explains when talking about her collection, she has purchased large quantities of both figurative and abstract art. She had allowed her eye to guide her—picking winners over and over, as both she and Lauren concede—but more recently, she has thought of *Lauren's* tastes and sensibilities. In her own words, "When you're going, you need to collect now what appeals to you. Not what appeals to me because I'm going to make an assumption that I'm not going to live with it as long as you will."

Audrey's primary mission is to form a collection that reflects history and also that she can pass on to her heirs. She speaks about "legacy" in an impassioned tone, talking in equal measures about the enthusiasm she feels for her art collection and the willingness to step back so that the next generation, in this case her daughter, can apply what they have learned and carry on with the process of cultural preservation. She also clarifies that, despite her track record of "picking winners," she has always purchased art based not on investment value but on what spoke to her personally.

Lauren has taken Audrey's devotion to art and culture and made it her own, even passing it onto the next generation,

exposing her children, Audrey's grandchildren, to art by hanging it in their bedrooms. There, she has displayed pieces that she describes as "very modern but very legacy." She talks about art in terms similar to Audrey's, emphasizing that she collects from a foundation of feeling, not any notion of status or competition. Reflecting on what she appreciates, she strives to support artists and preserve our heritage, viewing any appreciation in the works' value as substantially less important.

Asked about her inspiration as an art collector, Lauren is unequivocal. She says, "I don't know if there's anyone who has inspired me other than my mom." She talks about a string of prescient picks that Audrey made in the 80s, including Romare Bearden, Sam Gilliam, and the late Louis Delsarte. The inspiration that the daughter has drawn from this mother, daughter mutual interest has also extended outside the family, introducing art collecting to business owners and entrepreneurial women who want to do their part while also making investments.

When you listen to both women, mother and daughter alike, they seem eager to defer to each other, respecting the perception and sensibilities that they both bring to collecting. This respect, however, seems to come from different places. Lauren respects Audrey's skill and her deft-eye, recognizing how her years as a collector have made her capacity to spot developing talent inimitable. Audrey, flattered to hear this from Lauren, stresses the direction that her daughter has offered, describing her as "more forward-thinking."

The line of intergenerational collectors seems bound to continue on. Lauren says that her children adore art and enjoy meeting artists, recognizing the value in the events that she and Audrey organize. Art, for this family, is a means to gather people together—to celebrate music, food, culture, exploration, and connectivity, all from a fundamental understanding that they are working toward something even greater. Amid the fun and the bonding, they are on a mission.

Audrey says that when she started collecting, it was a solo venture. None of her friends were collecting art, but in her mind, she envisioned herself putting together a grand collection, one that she could donate to a museum. Despite collecting alone, she carried on, and because she did, her daughter's and her grandchildren's collecting experiences are altogether different. For them, art collecting is cohesive, something that they share.

Undoubtedly, there is joy in the art of collecting that Audrey and Lauren do. When they talk about it, they talk about it with their own vivid ideas, but there is an overlap between them and a tone that runs parallel in their voices. Audrey sees her children and grandchildren as the keepers of her legacy. If her words become illuminated when she is talking about *her* art collecting, they become blinding when she is talking about Lauren's and her efforts to push her collection beyond her lifetime. Through her vigor for art, she has created a system to preserve Black culture and heritage.

Chapter 14

Catherine E. McKinley

Art and the Connections that Matter – Collecting in a Personal Way

Collectors can often be quite varied and unique in their attitudes, exposure and approach. Many have such peculiar attitudes that those around them call them eccentric. Overall, a collector's ideals, mindset, and how they go about amassing their collection come to shape how they are perceived. This is why art collectors can be some of the most easily misunderstood people around. It's easy to see collectors as a privileged bunch, throwing their weight, along with their money, around, and buying the sweat off "lesser souls" to decorate their soulless residences.

But my interview with Catherine McKinley, an avid collector of African Photography and Prints, indicates why this is not always the case. Art collecting is emotional at its most basic level, and as I explore in this interview, those emotions can create connections that matter.

How it all started

For Catherine, born and raised in Boston before moving to New York, art was always a part of life. Her grandmother owned a

small art gallery in Stanford, Connecticut that Catherine said was more of a frame shop. While she never saw the gallery before it closed, there were several items from there around their house, and this made up her first exposure to art, although she never really made the connection until she got to college. Having majored in African American Literature, she first noticed art from the colorful covers in her school texts. According to her, these covers were "intense, yet so sensual and interesting" that she learned more about art and artists.

Her first collection efforts began in college and then, still at a young age, she bought her first piece of artwork, a Haitian painting by an artist in Jamaica. While she didn't love this first piece very much, she confirms that it helped her to get a feel for what works for her and what doesn't. She says, "To me, the joy of collecting is that you're educating yourself as you go along, so you have certain kinds of tastes or certain knowledge, but it's really through buying that you start to discern and figure out what your real identity is with collecting."

Several years down the line, Catherine has built an impressive collection of African photography, prints and artwork, based on the feeling of value she gets from them.

The connections matter most

Although, like most collectors, Catherine was exposed to art at a young age, she is unlike many others in the way she goes about her collection efforts. For instance, she fully entered her collection focus when she traveled to Ghana and other African countries while working on a Fulbright-funded book. Her journey was initially meant for research into indigo textiles but as she traveled, she became drawn to the history and tradition of indigo textiles.

While she didn't find the information she wanted, she found pictures, and according to her, these "were so amazing." From

that point on, she was drawn to African photography and on her journey through eleven other West African countries, she acquired more pieces of photography and sculpture. For her, the history of her collections and identity are fundamental. Catherine didn't know her biological parents and was adopted. As a result, her collection is underpinned by an obsession for portraiture as it helps her learn about *people, ancestry and inheritance.* Perhaps this is why, for Catherine, collecting is so personal. Most of her art was acquired directly from the artists. For her, this is a treasured way to create a collection as it means you create "artist relationships that are beautiful." While she has bought from fairs such as 154 and galleries such as Mary Boone, she believes that, in contrast, these venues foster a "sterile relationship."

As a case in point, she shares her experience with a major photographer who stayed at her house for a couple of days on a visit to New York. The relationship that emerged from that visit led to the photographer not only taking great pictures of her kids, but she was also gifted one of the photographer's well-known photos, with a touching note to boot.

That's why for Catherine, it's all about the relationships. She says, "I think the way that I've gone about it, I may have more access than some other people who have more money because I think it's all about relationships. Most artists love to make a sale and they need the money, but they also love the fact that you own it. I think we get stuck because of this idea of privilege and we think we have to have a certain kind of capital, but the capital may not be money. It can be a human capital. Artists love when you have their work because you know what it is, and you know who they are and you value who they are."

Collections, caring, and following the history

Catherine's values show perhaps most clearly in how much she loves to take care of her collection. The value is in knowing all

the little details about the art because it's much more than just a collection to her. She doesn't want to just own art; she wants to understand it and care for it. That, to her, is what being an art collector is all about.

She says, "*It's not an asset. It's not an art object. It's something I care about. I want to know how to take care of them. I want to know the history of it. I want to know what type of photo it is, where that fits in the line of history.*"

Catherine also believes that it is important for collectors to keep in mind that every piece of art you buy is like buying a piece of an artists' soul and that being able to peer into that work and see their soul really matters for many artists. Even if that's not their primary focus, artists still appreciate a collector who cares so much about the emotions evoked by their work.

In addition, Catherine believes that all collectors, especially those with Black-themed collections, need to keep the history and emotions of these works in mind. That is when such collections take on true meaning.

It was this spirit of caring that led her into buying a work from Mary Boone that, at the time, she didn't have the resources to pay for outright. Instead, she walked into the gallery and asked if they would take installments, and that was how she came to own such an impressive piece. Many other art collectors have built up impressive collections in this way, not because they had the capital for the works, but because they genuinely cared about owning them.

Future projections and paths

As with many socially conscious collectors, Catherine wants to make a legacy out of her collection, having worked on collaborations with artists and galleries in the US and African countries such as Ghana.

While she is still fleshing out the details of her legacy, there's no doubt that Catherine has built a collection more unique than most. And when her legacy finally becomes public, it's certain that we will all come to appreciate her collection that was built on the connections that matter.

Chapter 15

Keith Rivers

Discovering his passion for art after his rookie season in the NFL, Keith Rivers had been playing line-backer for the Cincinnati Bengals when he met the art history major who would show him around MoMA. A friend's sister, she took him on a tour of New York that included a trip to a Claes Oldenburg show, guiding him through sculptures and paintings and encouraging him to explore more about art himself. Barely out of his rookie season in the NFL, he was unsure how to proceed into the art world. As he puts it, "A friend of mine encouraged me to collect she gave me a better understanding about contemporary art that made me curious." His childhood spent much more on the football field than walking through museum hallways.

In time, however, Rivers appreciated art differently. He visited other museums, reflecting on art frequently on his own time. Because a close friend of his was an art dealer, he found himself with an inside connection to the art world, broadening his perspective and inspiring him to think about it more in terms of the conceptual ideas and not the objects themselves. Little by little, he educated himself about art, and the more that he learned, the more interested he became in it. Before long, he had purchased a few pieces for himself, starting out slowly but realizing that he had found something deeply invigorating.

Still early in his art collecting journey, Rivers visited a gallery in New York, and during that visit, he realized something about his collection: there had to be more to it, and he wanted to learn what those possibilities could be. His ideas about art were becoming richer, and sooner after, he watched *Art of the Steal*, a documentary about Albert Barnes, the chemist-turned-art collector who created The Barnes Foundation in Philadelphia. To Rivers, the Barnes story was a revelation: he saw what Barnes had done and the efforts he had made toward equal opportunity hiring, recruiting many Black people for his factory, where he would exhibit his art collection for them to enjoy—later donating his fortune to Lincoln University, a historically Black university, the first Black chancellor of which was a close friend to Barnes.

As Rivers describes it, "Looking at that story I was like I want to do something like that, me personally, I still don't know what I want to do with art, but I want to have some type of impact, through collecting. You know, being a person from the complete opposite field. And if I can do someday, be some kind of Barnes type collector I think would be an awesome opportunity."

Self-aware, Rivers describes the opportunities he has had to speak to children about their futures and how he knows his size (he's 6 foot 2, 230 pounds) has afforded him a career that would be unavailable to most others. His solution is sensible: he encourages children to look to artists like Kerry James Marshall for inspiration and to pursue a place in the museums alongside him, to seek more intellectual opportunities. Promising to do his part, he has since taken to viewing art in terms of its beauty and in terms of what it can do for the Black community, referring to the history that artists are building and the creativity that has defined it.

As an art collector today, Rivers seems to have added yet another layer of depth to his philosophy. Whereas he had first

looked beyond the objects to see the ideas, he has now looked beyond the ideas to see their impact. He talks about art collecting as a means of self-discovery, but he uses no general terms. His descriptions of art collecting clearly define the pursuit as a personal one, and he refers to his father, not knowing a lot about Black history, but "learning more about my Blackness" in a single breath. Art, to Rivers, is all-encompassing.

Now, not only a collector but a consumer of information, Rivers says that to understand artists more firmly, he looks to the books that shaped and influenced them. He points out James Baldwin and Ralph Ellison in particular. Exuberant about uncovering and finding art wherever it may be, he says that he attends shows as often as he can while also researching new artists and keeping up with art media.

Despite the breadth of his research and the expansiveness of his network, Rivers still talks about art as something visceral, making decisions about his collection not based on labels and trends but on what he appreciates personally. He mentions Kara Walker, Glen Ligon, and Barbara Kruger as artists whose work he collects, and despite their disparate styles and backgrounds, he sees interconnectedness among them all, referring to shared influences and the internal relationship that he feels with their work.

Rivers has embraced his position as an art collector as much as he has embraced collecting itself. He is a philanthropist, donating some art that he has purchased, such as three pieces to MOCA and one to the Tate, while also serving as a patron to young artists, facilitating the entry of the young artists' work into a museum collection. As an advocate for Black artists, he has worked with museums to help elevate artists whom he believes the art world has overlooked or failed to notice. Of all the museums he describes, MOCA is one that means a lot to him, both because of its proximity to USC where he went to college and because of their openness to exhibiting Black artists.

A world traveler, Rivers has toured the Prado and the Ludwig Museum and gone on trips to Dusseldorf, Paris, Rome, and London. He enumerates his experiences at these museums in loving and passionate terms, saying that for all the hours he spent there, he could have spent twice as many. The contrast between this and the beginnings that he also describes so openly could not be any greater: from someone who discovered an appreciation for art early on, he does not mince words about what art means to him—it means *everything*.

To those who are interested in learning more about art, his advice is direct and simple: "Go to museums." He encourages others to become involved in patrons' groups, find mentors, and work toward access to curators. His advice is to look out for young artists—both because they are more affordable and the opportunity to help someone who early in their career. Talking in this vein, his curious nature shines forth, and he advises aspiring collectors to read, watch YouTube videos of artist talks/lectures, and learn as much as possible, "collecting books before ever collecting art."

Enthusiastic about art as a tool for learning about oneself, Rivers also sees it as something that he can use to help others. It is no coincidence that Albert Barnes is one of his primary influences: combining art collecting, philanthropy, and business into one motivating, rousing story, Barnes lived a life parallel to Rivers' in many ways. Expressing a willingness to display his collection should someone express interest in it, Rivers is an art collector whose sincerity is an emblem for what art collecting can be.

Chapter 16

Craig Robinson

Craig Robinson—Pushing Back against Elitism from the Heights of the Art World

For Craig Robinson, art has always been a deeply personal endeavor, as he has navigated his art journey.

Craig Robinson grew up in an artistic family, his brother Janssen becoming a celebrated painter in their generation. Growing up in Atlanta, both young men appreciated art, and when their mother passed away twenty years ago and Janssen painted a touching oil piece in response, it was a turning point for him. Telling his brother that there was no way he could sell the piece, he held onto it because of the deep emotional connection that he had formed with it. That was the beginning of a lifelong journey into art collecting, one that Craig says he "maybe never intended to be serious really."

A graduate of MIT and Harvard, Craig became involved in art, volunteering and fundraising for the National Black Arts Festival. Every year, he would purchase more art, his collection growing. He would make his selections based on the same criteria that had moved him to hold onto his brother's painting—what moved and what spoke to him. Living in a two-bedroom condo in Atlanta, far from the spacious or luxurious space many people might imagine for an art collector, he was careful about every

selection because he did not have a lot of extra income. Far from the common perception of an art collector, Craig's upbringing and means were modest when he first took up collecting.

During his early days as a collector, Craig developed a habit that would stick with him for the rest of his life: he bought art that related to what was going on in his inner life, making his decision based on emotions. If there was something that seemed to speak to him on a personal level, then he would pay attention to it—and buy it. In 2008, for example, while Obama was running for the Democratic nomination, Craig found an artist whose work epitomized the inspiration that he felt seeing Obama on the national stage. He found the art irresistible because it connected to what he was going through, and following the artist's progress, he picked up several of his pieces.

Prior to that, he had purchased the poster for the "Million Man March"—a $25 purchase that belied his intimate approach to art. This has become a running theme throughout his life in the art world, the decision that he has made over and over again to listen to his gut and ignore trends. He is deeply honest with himself in that sense, always selecting his art as if he were selecting an extension of himself.

As for his brownstone, Craig says, "I really started to see my home as almost a museum space." He was filling his museum, of course, with pieces that meant a lot to him. His modest means growing, his approach to art stayed mostly the same, which meant that even when he passed from one artist to another, he was still purchasing and surrounding himself with art that he loved.

From his collection, Craig mentions pieces by James Van Der Zee. He talks about the intentionality with which he pursued his Van Der Zee prints—referring to it as a "hunt"—and speaks with pride about how more than one of those pieces features an original Van Der Zee signature in number-two pencil.

Throughout his search for Van Der Zee pieces, Craig visited multiple elite galleries and yet, despite the years he has spent

collecting and despite his more-substantial budget, he still gets the sense that he is somewhere the powers-that-be think, feel, and act as if he doesn't belong. As he puts it, "Like I need to count my money twice." He points out his education and his achievements, and despite all of this, in some places the message seems clear: that he is an imposter. He says that this elitism and its undertones have caused him to feel reluctant to become more formally involved in certain parts of the art world.

Meanwhile, Craig discovered the artist Karen Powell while she being showcased at festivals and less-prestigious shows. Over the years, though, her profile rose, and when he stumbled upon her at a larger and more exclusive show, he bought three more of her pieces. This is a routine that he describes enthusiastically, talking about his passion for finding artists when they are still up and coming and then pursuing them as they gain recognition.

Serving on the Acquisition Committee at Harlem's Studio Museum, Craig describes how the position solidified his sense of purpose in the art world. He explains that he had made a donation to the museum, doing his part to help them fulfill their mission. He also speaks excitedly about connecting with Harlem artists through the Museum, including artists whose talents are still developing.

Talking about *why* he prefers certain art over others, Craig is confident about his ability to communicate, even without the jargon and lingo that other serious collectors would use. Largely self-taught as a collector, he has cultivated his own sense of what he likes, leading to an original perspective. He describes how he has involved himself with other Black art collectors, organizing and hosting events where he could then expand his network further.

Collecting, perhaps just as much as art itself, seems to draw Craig insatiably. He talks endearingly about his collection of megalodon teeth, which he has framed in his home. More recently, he picked up black-and-white photographs,

(purchased directly from Adger Cowans), including some by a photographer who had inspired him to move to Harlem in the first place. Because of those photographs, he associated Harlem with a mystique, an intriguing place that he felt he needed to see and experience for himself, and now that he has and *is every day*, the photographs are akin to reminders of himself: how he has gotten where he is, the feelings that were there along the way, and what it all means to him.

Craig says, "I'm also very comfortable with art that makes people uncomfortable." He elaborates, explaining that he has collected some early-20th-century French posters that feature minstrel images of Black people. In the same vein, he mentions figurines, collectibles, and slave shackles that he has purchased. Of these, he says, "When I have events and I've hosted big fundraisers here, with Charlie Rangel, Cory Booker, Ethiopia's Ambassador to the UN, and others, and no one's going to come in here and not be affected by some of the stuff on the wall. And sometimes when I have non-Black people here, it's awkward, but part of it is I want them to feel awkward."

Asked what he would do with his art post-mortem, sell it or donate it, Craig says, "I feel compelled to make sure that the pieces are seen, and it is important that they are. It's going to be on a wall someplace where it gets seen and appreciated." He also acknowledges the economic side of art, how every transaction enables the artists to support themselves and to establish a market comparable from that sell. But for him, this is first and foremost a visceral pursuit.

In his own words, "It really is a leisure thing for me. When I have the time, I'm out and about, what I will do is I will get to know the artists if I can, but I have not committed myself in earnest." He says that he intends to learn more about methods and techniques in art, and to hear about his collection and the undeniable gems within it, to listen to him speak about how personal art has been to him, it seems inevitable that he will do just that.

Chapter 17

Elan Nieves

Elan Nieves Shares Her Experiences Collecting Art

Growing up, collector Elan Nieves found solace at the Metropolitan Museum of Art. The Met was a place of respite for the native New Yorker—but while visiting this treasured space, she never saw Black people as a focal point of the works on display. She felt they were consistently in the background, and so when she began collecting pieces of her own, she became determined to address this. To this end, Elan recommends that aspiring collectors navigate the industry with a specific objective in mind. They might work with an advisor, read books, or delve into the history of painting to understand how to best approach collecting. For collectors, the end goal is to explore what art they want to live with, and why. And so, they might attend galleries, ask questions, and think carefully about their approach. "If a work is in your home, you're going to see it every day," she says. "But your tastes will evolve, and that's okay. Be open to that change."

Elan attended school near Museum Mile, and regularly would visit the Museum of Modern Art and The Met with her family. She enrolled in art classes as a Hunter High School student, completing many of her assignments in the confines of her favorite museums. She shares, "The Met felt like home, and that I knew from an early age I would buy pieces of my own."

On Building an Art Collection

Elan received her first piece of art as a graduation gift. Her godmother's sister—an artist named Laurel Duplessis—was employed at the art museum at Virginia's Hampton University, and one day Elan went into her studio. As a gift, the recent graduate had the opportunity to choose any piece she wanted—and so she chose a canvas showcasing New Orleans. (Nieves did some pro bono legal work in the aftermath of Hurricane Katrina and that the piece was sentimental about a regional perspective.)

It was then that Elan committed to supporting artists and collecting meaningful work. "I thought that it was important to support some of my friends who are women of color, and who are people of the diaspora, so they could continue their art practice," she explains. Elan then set out to build a collection with social justice themes in mind. After completing her law degree, she continued to visit museums regularly, her focus shifting to collecting abstract works featuring people of color. Now, she embraces the ways abstraction has helped to create freedom from the form, so to speak. The collector's eight-year-old daughter has also brought to the forefront her desire to collect unique pieces created by artists to whom she and her loved ones can relate.

As a collector, Elan values the relationships she's cultivated with the artists in her circle. Though she's purchased works from auctions and galleries too, she finds buying from the artist particularly fulfilling. By connecting directly with the artist, Elan explains, collectors can understand the person behind the canvas. They can take the time to reflect on their story and background and determine what they—as a collector—have in common with them. Only then can collectors make the most informed decision, she states. Simultaneously, collectors can make further meaningful contributions by being patrons of

local museums, by visiting often and supporting these venues' events, by donating money or pieces to support a social specific cause, and by helping to promote exhibits—especially, for Elan, those focused on women and artists of color.

On Legacy and Abstraction

Legacy plays a vital role in Elan's approach to collecting art. The law school graduate wants her daughter to build powerful memories ignited by the works displayed in their home and likes to think she will hold on to many of these pieces. She envisions her cherishing them as tokens of their family. Again, this is where legacy comes in, and so Elan has made a point of collecting to support artists whose backgrounds and belief systems align with her family's. Yet, by focusing on abstraction, her daughter can see herself in the works on display in any way she chooses.

The abstraction certainly resonates. When her daughter was just three years old, Elan remembers the child—on a trip to The Met—looking at her and showing her the canvases by Jackson Pollock. Her daughter could barely tie her shoes, yet from an early age, she knew to recognize and celebrate Pollock's abstraction (something she'd picked up from a field trip). Now Elan takes pride in the fact that her daughter is so comfortable in art spaces. The young girl acknowledges that there are viable careers in the arts and enjoys accompanying her mother on studio and museum visits.

Regarding legacy, Elan is also fond of the written word. She keeps monographs of the art she most appreciates on hand. "I love learning about history, whether it's about a show or an artist," she says. Elan studied art history for a time in high school; she states she would have pursued it further if only those courses hadn't conflicted with her political science requirements. Today, though, perhaps, things have come full circle, as the arts play an integral role in her everyday life, as do social justice themes.

On Inclusivity and Representation

A celebrated collector, Elan admits she has always been interested in social justice and civil rights. By supporting artists, she believes that—besides her work as a lawyer—she can help to support causes she believes in. This is nothing new to Elan, who states that in the past she far too often (and for far too long) saw a lack of representation in museums, at galleries, and even in people's homes. When she was older, she decided, this would no longer be the case. And so, Elan Nieves the collector decided to be involved in whatever capacity she could to ensure museums weren't lacking in representation.

The fight to celebrate the unseen has brought about a lot of change in recent decades, although more work still needs to be done. Elan is optimistic about the trajectory of the art space, and she believes the industry is substantially more inclusive than it was 30 years ago. This, she finds, is great for artists of color who might not have dreamed big. But what will the future bring? Likely a space where people can address social justice issues in their work, feature voices of the diaspora, and openly discuss the gaps that need to be filled. Elan, as a collector, mother, and human being, pledges to continue working to support this much-needed representation.

Chapter 18

Everette Taylor

A tech entrepreneur and art collector, Everette Taylor is a driving force in both of his chosen fields.

In the last few years, he has rapidly ascended to the heights of the tech industry, appearing on the Forbes "30 Under 30" list for his work in marketing in 2018. More recently, he has moved to New York City and stepped into an executive role at Artsy, the leading online platform for fine art, becoming the Chief Marketing Officer (CMO) and both the youngest executive and the only Black executive at the company. At the same time, he has carved out his reputation as an art collector, building up his collection from nothing to over sixty pieces in just three years.

Everette's path to this point has been remarkable—and anything but assured. Growing up in Richmond, he encountered significant difficulties when he was an adolescent, running into some trouble in his South Side Richmond neighborhood. When he was fourteen, his mother forced him to find a proper job, working before and after school and all day every weekend. This was the beginning of a challenging period of his life for other reasons, though. After some family financial issues, he became homeless, and at seventeen, took refuge in the public library. Difficult as all this was, it was also the first time he accessed a computer independently.

Discovering the internet and technology relatively late, Everette learned all about Mark Zuckerberg, Facebook, and other entrepreneurs in New York and Silicon Valley, and this was a revelation for him. He uncovered a passion for technology and for education that had lain dormant all his life up to that point. This was a critical moment in his development as a person, his direction before then tenuous. Once he saw how he could use technology to change the world, he dove headfirst into it, studying all that he could on his own. He also resolved to go on to college. In his own words, "I would wash windshields and do whatever at gas stations to save money. I saved enough money to apply to one university. I applied to Virginia Tech because they had tech in the name."

After his freshman year at Virginia Tech, Everette was up against yet another family financial issue, and to support his mother, he needed to drop out and look for another job. Although he was devoted in his search, he came up short, which was when he chose another way: entrepreneurship. Launching his debut company, EZ Events, he built up a business from scratch over the two years that followed, selling it when he was 21 and using the proceeds to return to Virginia Tech.

His second time around, Everette pledged a fraternity and recommitted himself to learning. Soon after, though, he was considering dropping out again, this time not to support his mother but to pursue a career in technology. He headed west and built multiple successful tech companies, distinguishing himself through the results. Every step of the way, he remained focused on helping others—on working for positive change. He recognizes the uniqueness of his situation. As he puts it, "Being in a C-level position, especially Artsy, which is the biggest online art company right now. To be in that position at 30 years old and Black is rare, but I put in the work too. I went there because I wanted, not for money, but because I wanted to actually make a change."

Similarly, Everette has followed a one-of-a-kind route in art. He says that art was part of his life when he was growing up, and he points, as early influences, to the street art and graffiti art that was around Richmond as his introduction into the field. He also highlights his propensity to read book after book when he was younger, devoting hours upon hours to Basquiat and Keith Haring—whatever he could find in his public library. In school, on the other hand, it was another story, his art teachers trying to nudge him away from the abstract art and street art that he loved. He says, "I just loved that kind of rebellious nature of it. But when I got that C in art, I was like, man, like forget this stuff, you know."

Drawing his own art, studying art, reading about art, Everette points to an ex-girlfriend as the impetus for his awakening into art as a serious endeavor. He describes a point in his life when he had stopped paying as much attention to art, his time and attention devoted to his technology career and refers to her as a spirit guide, introducing him to LACMA, MoCA, The Underground Museum, The Broad, and the California African-American Art Museum.

Incredibly, it was neither an exhibition nor an auction that jump-started Everette's collection: it was a raffle. Purchasing two $20 tickets, he won a piece that would change his entire life. He says, "I probably would have eventually become a collector at some point. But it probably wouldn't have happened anytime soon if that didn't happen, right?" He says that within the same month, he purchased other pieces that spoke to him. He says, "I don't have any tattoos, but a lot of people who tell you that they have tattoos, you get that one, one tattoo—and it is addictive." That was it for Everette; that was "the spark."

When he is discussing the state of the art world, he refers to the rising prices as a net-negative because of its deleterious effects on Black collectors, or other prospective collectors, who are looking to get their start. He also speaks passionately about

the rupture in the bond among artists, gallerists, and young collectors, emphasizing the mutual benefits of mentoring. This is an area about which he seems especially interested, tying it into the work that he is doing through ArtX, saying, "I was inspired to create this platform because I wanted to tell diverse artist stories. I wanted to be able to empower them, give them resources and tools to be successful."

As a collector, Everette says that his approach diverges from that of many others. He says that he does not plan on selling any of the works he has purchased, thinking of them as decidedly his own and explaining his plans to launch a space to showcase them or to donate them somewhere for display. For him, art and money are as separate as they can be. He cherishes the role he is playing in the art world, valuing the historical impact of the artist and priding himself in his ability to push this forward.

Everette's collection includes artists whose clout is significant: Derrick Adams, Vaughn Spann, Kevin Beasley, Torkwase Dyson, Sam Gilliam, Debra Roberts, Amoako Boafo, and Henry Taylor. Of the Henry Taylor piece, he relates its importance to him, saying that he had wanted to own one of his works for some time before meeting him one-on-one, spending an afternoon with him, and building a relationship with him over the year that followed—hoping all the while that the artist would paint him, only for it to happen on his last night in Los Angeles before he moved out to the East Coast to take his role at Artsy. He says that Mariane Ibrahim, a Black gallerist in Chicago, showed him the Amoako Boafo piece, and it stunned him. He missed out on a piece for that sold for $3,500. Today, he could easily sell it in the six-figures. Although, he acquired a Boafo work shortly after (albeit at a slightly higher price).

For Everette, the purpose of art is art itself, and as a buyer, he says that he only thinks of finances to help the artists themselves. He is devoted to giving back to the community, standing up for the art that he did not see growing up in Richmond and

that remains out of reach for so many others. He says, "One of the things that I'm almost jealous of with artists is that when you make art, man, that's your legacy. As a collector, it's like, what can I do? You know, I can't paint for shit. What can I do to impact people later on? It's not about things, and I don't care if I'm personally recognized for what I do. It's about doing things that are going to inspire and affect people generations to come."

From teenage homelessness to a world-class art collection, Everette has lived on the extreme sides of life. Seeing things that he wanted—a career in tech, a Henry Taylor painting of himself, a collection he could be proud to share, knowledge, achievement—he pursued them with ferocity, barreling through the barriers that would have seemed insurmountable to somebody else.

Chapter 19

Virginia Williamson

Virginia: Art Collector and Recent Harvard Law School Graduate

There are times Virginia wishes she had started her art collection sooner. The 30-year-old Harvard Law School alumna uses Instagram regularly to connect with artists and build her body of work. She likes to reach out via direct message, tell up-and-comers she appreciates their art, and purchase her favorite pieces in just a few Venmo clicks. The process is simple, really. It allows her to fill her space with works she loves, and it allows her to support emerging artists whose pieces so often resonate with her.

Growing up in suburban Maryland, Virginia tells me art played an indirect role in her life from a very early age. Her grandfather was an artist; he taught classes in the county jail system for over three decades, and her parents kept a number of his pieces lying around the house. There was always a sense, she explains, that art was valuable—that it was something to be appreciated. And so she would examine the art they hung at home, and she would frequent portrait galleries and museums in Washington DC (and in her parents' native Chicago, where the Art Institute quickly became a family favorite).

One might say Virginia's upbringing led to the purchase of her first original work in early 2017—a piece called "They're

Gathering" by Los Angeles artist Michelle Robinson. Virginia tells me she was distraught by the outcome of the 2016 U.S. presidential election, and that the piece deeply resonated with her during this time. She was clerking for a judge in DC, which meant she couldn't visibly participate in politics; though she respected these restrictions, she still wanted to voice her frustrations, and Robinson's piece allowed her to do just that. The canvas, which featured a group of nude women with their arms outstretched, made Virginia think of the Women's March—and so she promptly sent an email to Robinson on social media.

To this day, social media plays a massive role in Virginia's search for new pieces. She appreciates that artists will share one another's work on Instagram, just as she tells me she appreciates how easy it is to discover emerging talent, and how simple it is to Google emerging artists and gain a clear and immediate sense of their portfolio. Virginia also attributes her experience as a collector to former Metropolitan Museum of Art social media manager Kimberly Drew, whose blog she follows somewhat religiously. Her affinity for social media has led to the purchase of prints from artists like Malik Roberts, Yoyo Lander, Jeff Manning, and Deborah Cartwright. Most recently, she's added original works from artists like Tiffany Alfonseca, John Rivas, Khari Turner, Brittany Tucker, Chigozie Obie, Paul Verdell, and Brittney Leeanne Williams to her collection.

Ask Virginia what motivates her as a collector, and she'll tell you the extent to which she emphasizes legacy. "Every time I buy a work, I know that I will have it for 50 years, and I will pass it on to somebody in my family," she explains. "I do not ever buy a work thinking that in two years I can sell it for a profit." Though she admits she's hopeful, on some level, that the pieces will increase in value over time, she doesn't plan on selling them in the near future—and she's all the more focused on her artists' success. "Monetary value does not drive any of my purchasing decisions," she adds.

The collector makes a point of supporting artists of color. She discloses those pieces that capture a sense of Blackness touch her on a personal level, and that perhaps she does lean more toward artists who incorporate this Blackness into their work. Ultimately, though, Virginia strives to collect the type of art she wants to see in her home. Collecting is an emotional experience; there's a great deal of regret involved in the process—of wishing you had moved more quickly, or that you had invested in an artist while they were still within your price range. Then, there is the frustration of wishing you could more easily decide between two pieces when you only intend to purchase one. Virginia urges young collectors to conduct ample research before they buy—and to follow their instincts as much as possible.

Yet, Virginia understands that we must live and learn. And while she isn't planning to hold a show anytime soon, she tells me she wouldn't be opposed to exposing her collection to the world in a decade or so. For now, she explains, having friends and family come over to catch up, and to view her work at home, is more than fulfilling enough.

Chapter 20

Ernest Lyles

Building an art collection through cultivating relationship

Ernest "Ernie" Lyles tells me that growing up; art didn't play a significant role in his life. In fact, he admits he hated art class in his youth. Today, the law school graduate turned investment banker is so fond of the arts that he's made a name for himself as a collector. He first got involved in the space as a student at Howard University, by visiting the National Art Museum in his leisure time. "It was a perfect mental break," he says. Pausing for a moment, he adds, "It was also a helpful thing to mention when I was single."

And so Ernie began building his art collection in 2012 and became more focused in 2014. He remembers the evening a friend hosted an art auction—a fundraiser for Ethiopia—an event during which he made his first purchase. Though the art itself wasn't an essential part of his story at the time, it marked a turning point for the Founder and CEO of the HiGro Group—that is, a newfound desire to see and experience more. Nowadays, the collector relies on his close friend, artist Derek Fordjour, for insights into goings-on in the art space. Fordjour was in residence at the Sugar Hill Museum of Art and Storytelling when he and Ernie met, and, in the collector's words, "Fordjour had

the best way of breaking down how I should parallel my taste in art with my understanding of markets and finance."

Now Ernie makes a point of consulting Fordjour before each purchase (and naturally, he owns several Fordjour paintings). Also, YoYo Lander's canvases, Zoraida Lopez's photographs, and other works by Maria Font can be found in Ernie's collection. The collector has also honed in on emerging artists like Kenrick McFarlane; admittedly, as his eye matures, his tastes have begun to lean more figurative than abstract (although Ernie appreciates Vaughn Spann and similar abstract artists). Above all else, the collector wants the artists in his circle to know they can count on him to support their careers in any way possible.

How will Ernie's experience as a collector progress? He prefers adding to his collection direct from artists to acquisitions at galleries, auctions, and fairs (although he recognizes these are viable alternatives—and critical methods for artists who wish to scale their careers). When it comes to buying art, however, Ernie learns most effectively from speaking directly with others. "I am a relationship person," he says. "Intermediaries are good, but no one can tell a story like a person who has experienced the story." In this way, Ernie's approach to collecting is intimate. He likes to know the artists in whom he invests on a personal level, because the collector considers each purchase an entry into the artist's family if you will.

Similarly, Ernie wants his young daughters to know the story behind each piece. To this end, culture and imagery are no less vital to his collection. The collector's lens for learning is based on whether the imagery builds upon—in Ernie's words—his seven-year-old's "spirit and understanding" of the world around her. "The art does not need to be figurative or G-rated," he explains. "It can be risqué, but it still needs to have a presence." Family and legacy are invaluable to Ernie, and accordingly, his collection is curated and personal in equal measure. He often sits down with his wife before making a

purchase, discussing the collection as a whole and the artists who might be a good fit. "Occasionally, she sees a twinkle in my eye and says, 'Just go for it,'" he laughs.

Ultimately, Ernie doesn't chase opportunities. In business and art, he views every acquisition as entry into a partnership—and if the other party doesn't want to partner, then that's okay—it has to be. (The same applies to love, the collector explains, though he is now happily married.) Because above all else, Ernie believes people need to invest in relationships. "When you trust someone deep in the art world, listen to their advice," says Ernie. "Even when it feels uncomfortable." This is something all collectors would do well taking to heart.

Chapter 21

Conservation, Installation, Transportation, and Insurance

Understanding conservation, storage, and insurance

Through art conservation, we can preserve our cultural heritage for the next generation. Here's how to get started.

Getting your start in art collecting, you are likely to encounter at least a few challenges. Before you pick up your first piece, you likely fall into one of two mindsets: you think collecting is too complex even to wrap your head around, or you think it is as simple as buying something and putting it into a frame. The reality is somewhere between these two extremes. While there are details and nuances to learn, there are definite steps that you can follow to cut your learning curve and make the most of all the time and effort you put into your collection.

The first step in this process is to ask questions. Ask questions right at the beginning, at the point of sale or before you buy. That is your opportunity to learn as much as you can learn about the piece you are collecting. You should already know the artist's name, the dimensions of the piece, the materials,

and the cost. From there, you get a little more in depth. Jonna Twigg, an art conservator and founder of Twigg Bindery says, "ask if the piece is framed or mounted, and if it's framed, ask who did the framing, if it is of archival/museum quality if the glazing is UV-protected, and what the backing board consists of," and "For three-dimensional works, look at the base, what it's made of, and how you will install it. For every piece, consider installation, including the hardware you need to hang it and whether or not your floor or wall can support it."

This tact will enable you to exhibit the art, but that is not the end of the process. Next, you need to figure out what documentation is available. The more documentation there is, the more clearly you can establish the authenticity of the work. This is not only for your peace of mind, either: it could affect insurance and future appraisals. Plus, documentation, labels, and other information enhance the storytelling value of each piece of art.

Before the art ever gets from the buyer to its destination, you need to think about transit too. This is the *number-one* source of insurance claims in art, and to avoid that process altogether, you need to make sure that your art gets wrapped, packaged, handled, and shipped according to best practices—which an art services company can facilitate.

Meanwhile, insurance is an ongoing concern. There are many options for art insurance. Which insurance you choose is a personal decision, but know your homeowners' insurance may not cover art. Prices differ depending on the level of service, art's current market value, which a claim would payout, and a variety of other factors. The best policies will cover almost all situations, but your sharpest first defense is still everything is within your control: installing and storing your art properly. Also, be sure to control the climate in your space. The more you can parallel the methods of an art gallery or museum, the better off you and your art will be.

So, your art is finally at its destination, and you feel you have taken care of all the details. Now what? Jonna advises, "As an art collector and art you have a duty to preserve cultural heritage through vigilant care, reducing any potential hazards by considering the environment in your storage space, home, and exhibition space. Think about light, temperature, humidity, pollutants, pests, and how each of these factors could alter or damage the materials specific to your art."

Using archival materials and fostering a sense of awareness about your collection, you should be able to set your collection up for the long haul. If you are confused about anything, contact a conservator for some insight. National cultural institutions such as the Library of Congress, The National Gallery, and The Smithsonian can all help with this. Over time, it will make sense and seem as intuitive to you as admiring and recognizing art itself. The important thing is to continue to ask questions.

Afterword

Most of the materials in this book come from my own experiences and adventures. After completing my MBA in Finance, I worked in the financial service industry, while building my collection of contemporary art. After completing a second Masters in Museum Studies at Harvard University, I started writing about art for journals like *Artnet* and *Artsy*. Through these experiences I learned the techniques of interviewing. Although, some materials include artists I had no access to because they are no longer alive, or I had no connection to them, when possible I was to speak directly to artists like Derrick Adams, Renee Cox, Mario Moore, among others. This helped validate the material from these artists because the source was their own mouth. I really hoped that my academic training did not come out too much, so I elected to use little academic jargon, and did away with footnotes to distract the reader. As stated further, this is not an art history book, having only named 20 or so artists. This would do little to that extent.

I put the heavy stuff in the beginning. Chapter 1, again, is not a comprehensive list of books that one must read to learn about art and art history, but merely a few books that I consider great for a solid foundation. John Berger's *Ways of Seeing* had to be included. I remember writing my first paper at Harvard on Kiki Smith. My professor challenged me to read this book

in order to revise a single paragraph in the essay which she stated could not be removed. Ralph Ellison's *Invisible Man*, was added later on. It just kept coming up. Kerry James Marshall mentioned it in a lecture he did at the MCA. Collectors Hill Harper, Keith Rivers, and Craig Robinson all mentioned the book in their interviews with me. So, I read Ellison's book for the first time while writing and knew it had to be included.

My first disclaimer is about previously published work. Some of this material results from previous interviews I had. Because I had the luxury of sitting down for long interviews with Derrick Adams, Howardena Pindell, Mario Moore, Renee Cox, I was able to take some material from our interviews to construct a new essay. First, Derrick and I sat down in November 2019, for a Q/A I had published in *Artnet*. Howardena and I sat down a few weeks after that for an *Artsy* piece. Renee and I did multiple interviews over four months, from December to March 2020. Mario and I did a phone interview, and the original piece is due to show up in *Fine Art Connoisseur* magazine in September 2020.

As you may have noticed, I speak extensively about advice. I think sound advice saves you two things: time and money. Wealthy people are time-poor. And poor people, well, they may also be time-poor, but they're definitely capital challenged. Some do not have the time to waste on researching for art, and others cannot afford to have misguided purchases. And there's everything in between. I included Alaina Simone, who does so much and knows so much, it's really hard to even give her a title. She knows more about African American art history than a lot of PhD's. I met Anwarii Musa by chance and I realized more and more when we spoke how much he really means to his clients. I think working with his company, Artmatic, a new collector or a seasoned collector can benefit highly from their services.

I spoke to quite a few young artists while writing. There were two that stood out. Khari Turner at Columbia University

and Alisa Sikelianos-Carter at the NXTHVN artist residency. All I can say is: Go see their work as soon as possible. You'll thank me later.

The meat of this book is the chapters on art collectors. I don't have access to art collectors, so I was at the mercy of kind introductions from people like Alaina and Anwarii. I met Lauren, Audrey and Elan through Alaina. Anwarii introduced me to Keith Rivers. I randomly met Everette and Catherine from searching the internet. I first met Hill at a private dinner organized by Fridman Gallery in New York City in celebration for Nate Lewis' first solo show. We remained in touch and he graciously accepted my request for an interview. The one anonymous collector "Marcus," I met at a post Amory art fair event in New York City. Catherine introduced me to Jonna Twigg, an art conservationist, who provided insight for the section on conservation, installation and insurance. The story of meeting Craig is interesting. We met at a Harvard Club of NY zoom networking call. I noticed the art in the background and sent him a private message asking about his art.

I want to also pay tribute to the late great Ed Clark. My first opportunity to publish publicly came on an art I did for his Hauser & Wirth show in NYC back in October 2019. I was invited to pitch a story for an article and (on a suggestion from Alaina Simone), I included him in one of the pitches. *Artnet* jumped on the story. An artist friend of mine, Tariku Shiferaw, introduced me to one of his previous gallerists, Alitash Kebebe, and she really gave me most of the information I used for that article. Afterwards, I begin to explore his work more and more. He died shortly after the article I wrote was published. I'd like to hope he got a chance to read it, but I don't know. However, it was an honor to be part of that show in some way. I continue to explore and learn more and more about his work.

I close in to whom I dedicate this book. My great debt is to my mother. She's the first art collector I have ever known.

I remember her spending more money than she probably should've in the late 80s and early 90s on art. She always talked about supporting Black artists and described why she thought it was important to see images she related to in her home. Without those early experiences this book would not exist. Thanks Mom.

Glossary of Essential Art Terms

Abstract Art: Non-representational works of art that do not depict scenes or objects in the world or have discernable subject matter.

Accession Number: A control number unique to an object, used to identify it among the other objects in that collection. It is part of the numbering system encompassing the permanent collection of an individual or an institution, and reflects the transaction making an object a part of that collection.

Amateur: Non-professional or inexperienced artist.

Appraisal: The evaluation of a work's market or insurance value. Appraisals can be offered by galleries, experts and auction houses.

Art Criticism: Is the discussion or evaluation of visual art. Art critics usually criticize art in the context of aesthetics or the theory of beauty.

Art Dealer: A person who buys and/or sells art professionally; public or private.

Art Historians: A person who studies objects in their historical and cultural contexts. Art historians often are experts in some particular era of art history.

Artist's Proof or AP: They come about when an artist is creating a series of prints and receives proofs to check quality and color. If the artist decides to sell them, they will come at a premium price, due to their limited number. These are considered a status symbol in the world of art collecting. In French it is known as épreuve d'artiste.

Authenticity: A work of art is considered authentic.

Avant-garde: The term means any artist, movement, or artwork that breaks with precedent and is regarded as innovative and boundaries-pushing.

Blue Chip: Refers to artists and their work that is expected to hold or increase in value no matter what because their place in art history has been fortified. This can also include art galleries, as they are typically only showing works of art by blue chip artists.

Canvas: Is a closely woven cloth, usually linen, used as a support for paintings.

Catalogue Raisonné: The typical catalogue raisonné is a monograph or series of books giving a comprehensive catalogue of artworks by an artist, either in a particular medium or all media.

Chiaroscuro: Is an Italian term which literally means "light-dark." In painting, chiaroscuro generally refers to clear tonal contrasts used to suggest the sense of volume of the objects depicted.

Collage: Refers to the resulting work of art in which fragments of paper and other materials are arranged and glued or otherwise affixed to a supporting surface. Usually a single surface is used to create the work of art.

Conceptual Art: The emphasis of ideas over objects and that the idea itself, even if it is not made visual, is as much of a work of art as any finished product.

Copying: Forms of artistic imitation and emulation.

Critic: A person who analyzes, evaluates, or expresses an opinion on a work of art.

Criticism/Art Criticism: The analysis, evaluation, interpretation, and study of works of art. Art history and art criticism are intellectual activities aiming at the study, comprehension, and interpretation of works of art.

Cubism: A style of painting and sculpture making, characterized by an emphasis on formal structure, the reduction of natural forms to their geometrical equivalents. It is considered a movement that started in the early 20th century and continues till this day.

Curator: Is an overseer or keeper of cultural heritage, i.e. art, typically at an institution, but could be independent. A curator often selects and interprets works of art for an exhibition, public or private.

Decorative Arts: Are arts or crafts concerned with the design and manufacture of beautiful objects that are also functional. Often a term misused or intentionally used to mislabel art by people of color. See 'Fine Art'.

Digital Print: Any print that incorporates digital technology into the creation of an image or its printing.

Diptych: A work of art consisting of two sections or panels, usually hinged together, but can be separate pieces.

Drawing: Pencil, pen, ink, charcoal or other similar mediums on paper or other support, tending toward a linear quality rather than mass, and also with a tendency toward Black-and-white, rather than color. A unique work of art, often on paper, made with dry or wet mediums, including pencil, charcoal, chalk, pastel, crayon, pen, ink, watercolor, or oils.

Easel: An upright frame for displaying or supporting a canvas while the painter is at work.

Edition: (typically a print, sometimes a sculpture) A set of identical objects made from the same printing surface. Editions may be limited or unlimited in number. See also 'Open Edition'.

Exhibition/Art Exhibition: Is the space in which art objects meet an audience, universally understood to be for a temporary period, making it fundamentally different from an art collection.

Exhibition Catalogue: Documents the contents of an art exhibition, ideally providing a forum for critical dialogue between curators, artists and critics. It can be in the form of a book or pamphlet. It can also be digital.

Faux: French for false, artificial, fake.

Figurative: Is often used simply to mean that an image contains recognizable images. Those images can be people, animals, and/or objects.

Fine Art: Is art developed primarily for aesthetics or beauty, including its intellectual properties. It also denotes art created by artists who are highly skilled and often classically trained.

Flipping Art 'flippers': A person or group of people who buy and sell art to turn a profit. Most flipping is done by art collectors as a way of making money to reinvest and expand their art collection or to take advantage of short-term arbitrary swings in the art market.

Found Object: An object—often utilitarian, manufactured, or naturally occurring—that was not originally designed for an artistic purpose, but has been repurposed in an artistic context.

Glaze/Glazing: Consists of brushing a transparent layer of paint on top of a thoroughly dried layer of opaque paint.

Glossy: Surfaces which are lustrous, shiny, and smooth.

Installation: An art form that comprises visual elements in any medium and the space they inhabit. Installing art can also be a term used to describe hanging art in a private or public space.

Institution: A term often used to describe private places that own art. This could be art museums, foundations, or collections. These places rarely sell art works and often they are given early access to purchase works of art in high demand.

Institutional Critique: Centered on the critique of museums, galleries, private collections, and other art institutions.

Mass production: The production of large amounts of standardized products through the use of machine-assembly production methods and equipment. This term is often used to describe artists who produce works at higher rates than normal or the works of art in open edition that are produced in large quantities.

Masterpiece: Is a term now loosely applied to the finest work by a particular artist or to any work of art of acknowledged greatness, or of preeminence in its field.

Medium: Painting, sculpture, drawing, printmaking, are all media of art in the sense of a type of art; however, the term can also refer to the materials a work is made from. Some of the most popular artistic painting mediums are: acrylic, encaustic paint, gouache, oil, tempera, watercolor.

Minimalism: Characterized by simple geometric forms devoid of representational content.

Mural: A large painting applied to a wall or ceiling, especially in a public space.

Muse: Can refer in general to a person who inspires an artist, musician, or writer. Often, in art, it refers to a person when an artist references them in their work often and frequently.

Narrative: Term used to describe art that provides a visual representation of some kind of story.

Oil Paint: A painting medium in which pigments are mixed with drying oils, such as linseed, walnut, or poppy.

Old Masters: Refers to great European painters practicing during the period roughly 1300–1830.

Open Edition: An edition, print or other object, that can have an unlimited number of examples.

Paintings: Are made of organic and inorganic materials, which are put together by an artist to create a specific image. They form a simple construction consisting of one or more paint layers and a support for those layers. The paint is put on an object to create a work of art.

Palette: The surface on which a painter mixes his colors. Also, the range of colors used by an artist.

Patron: Often referred to a person who supports the arts. This support can be in the form of commissioning works by an artist, donating works to institutions, or donating money to institutions to help them continue their mission. Patrons are often rewarded with board seats, first access to artworks, or the ability to influence decisions by artworld professionals that shape the market.

Patina: Is a tarnish that naturally forms on the surface of copper, bronze, and similar metals and stones.

Pigment: Is the element in paint that provides its color. Pigments can be made of a wide range of materials, including minerals, natural and synthetic dyestuffs, and other man-made compounds.

Pop Art: Borrowed imagery from popular culture—from sources including television, comic books, and print advertising, as well as other methods of production drawn from the commercial world.

Portrait: Is a painting, photograph, sculpture, or other artistic representation of a person in which the face and its expression are predominant.

Primary Art Market: This is when an artwork is sold, and its price gets established for the first time. Art on the primary market often comes directly from an artist's studio and work is sold to its first owner.

Print: A work of art on paper that usually exists in multiple copies. It is created not by drawing directly on paper, but through a transfer process. Four common printmaking techniques are woodcut, etching, lithography, and screenprint. Prints can be limited editions or unique works.

Private collection: This is a privately owned collection of artworks, usually by an individual art collector. However, it could also refer to the collection of a company or other organization, such as a bank or law firm. Any work that, by nature, the public does not readily have access to.

Provenance: Refers to the chronology of the ownership or location and history of an object. Often, provenance helps determine authenticity and can create additional value of a work of art. An artwork's provenance is the record of its history, ownership, and origin.

Realism: A type of representational art in which the artist depicts as closely as possible what the eye sees. Realism attempts to represent people, objects, or places in a realistic manner.

Retouching: Describes the work done by a restorer to replace areas of loss or damage in a painting.

Screenprint: A stencil-based printmaking technique in which the first step is to stretch and attach a woven fabric tightly over a wooden frame to create a screen. Areas of the screen that are not part of the image are blocked out with a variety of stencil-based methods. A squeegee is then used to press ink through the unblocked areas of the screen, directly onto the paper.

Secondary Art Market: This is the world of re-selling artworks, through galleries, dealers, or at auction. The secondary market usually occurs when an artist is established and sought after.

Silkscreen: A stencil-based printmaking technique in which the first step is to stretch and attach a woven fabric tightly over a wooden frame to create a screen. Areas of the screen that are not part of the image are blocked out with a variety of stencil-based methods. A squeegee is then used to press ink through the unblocked areas of the screen, directly onto the paper.

Sketch: Is a rapidly executed depiction of a subject or complete composition, which is usually produced in preparation for a more detailed and completed work.

Still Life: A painting in which the subject matter is an arrangement of objects—fruit, flowers, tableware, pottery, and so forth

Studio/Workshop: Is an artist's or worker's place of work.

Timelessness: The notion that certain works of art are so filled with genius that they rise above the specifics of time and place

to occupy a transcendental, superhuman plane of existence that does not belong to history.

Title: A name that identifies an artistic work.

Triptych: A work of art consisting of three sections or panels, usually hinged together.

Virtuoso: is an individual who possesses outstanding technical ability in a particular art or field such as painting. Virtuoso also refers to a person who has cultivated appreciation of artistic excellence, either as a connoisseur or a collector.

Visual Arts: are art forms such as painting, sculpture, architecture, drawing, printmaking, design, crafts, photography, video, and filmmaking.

Watercolor: paints composed of pigments ground to an extremely fine texture in an aqueous solution of gum Arabic.

References

Cover

Designed by Keviette Minor
www.kevietteminor.com
www.instagram.com/keviette.by.design

Foreword

Alexandra M. Thomas
www.twitter.com/_aly_tho_
www.linkedin.com/in/alexandra-thomas-7b2b9910b/

Introduction

Banksy, Rhys Ifans, and Shepard Fairey. Exit Through the Gift Shop. United States: Mongrel, 2010.
Figuring History: Robert Colescott, Kerry James Marshall, Mickalene Thomas, 15 Feb.–13 May 2018, Seattle Art Museum, Washington.
Freeman, Nate. "Record-Breaking $110.5 M. Basquiat Shocks Attendees at Sotheby's $319.2 M. Postwar and Contemporary Evening Sale." ARTnews, 18 May 2017, www.artnews.com/art-news/market/record-breaking-110-5-m-basquiat-shocks-attendees-at-sotheb ys-319-2-m-postwar-and-contemporary-evening-sale-8374/

Graustark, Barbara. "Sean Combs Is Revealed as Buyer of Kerry James Marshall Painting." *The New York Times*, 18 May 2018, www.nytimes.com/2018/05/18/arts/sean-combs-kerry-james-marshall.html.

Kazakina, Katya. "Alicia Keys, Swizz Beatz Snap Up Work From In-Demand Artist."

Bloomberg News, 27 Jul 2019, www.bloomberg.com/news/articles/2019-07-26/alicia-keys-swizz-beatz-snap-up-work-from-sought-after-artist

Moore, Charles. 2019. From Exclusion to Inclusion: Connecting Black Students to Art Museums. Master's thesis, Harvard University DCE.

Soul of a Nation: Art in the Age of Black Power, *14 Sept. 2018–3 Feb. 2019, Brooklyn Museum, New York.*

Wall Street. Directed by Oliver Stone, 20th Century Films, 1987.

William W. Fisher III, Frank Cost, Shepard Fairey, Meir Feder, Edwin Fountain, Geoffrey Stewart & Marita Sturken. *Reflections on the Hope Poster Case*, Harvard Journal of Law & Technology Volume 25, Number 2 Spring 2012

Chapter 1

Album Cover
Graduation by Kanye West

BOOK LISTS
Carrie Mae Weems: Three Decades of Photography and Video by Kathryn Delmez
Collecting African American Art: Works on Paper and Canvas by Halima Taha
Consuming Stories: Kara Walker and the Imagining of American Race by Rebecca Peabody
Dandy Lion: The Black Dandy and Street Style by Shantrelle P. Lewis

Henry Taylor by Charles Gaines

Invisible Man by Ralph Ellison

I Too Sing America: The Harlem Renaissance at 100 by Wil Haygood

Kerry James Marshall: Mastry by Ian Alteveer, Helen Molesworth, et al.

Race Matters by Cornel West

Samella Lewis and the African American Experience by Samella Lewis

Stony the Road: Reconstruction, White Supremacy, and the Rise of Jim Crow by Henry Louis Gates Jr.

The American Century: Art & Culture, 1900-1950 by Barbara Haskell

The American Century: Art & Culture, 1950-2000 by Lisa Phillips

The Lives of Artists: Collected Profiles Hardcover by Calvin Tomkins

Ways of Seeing by John Berger

Ways of Looking by Ossian Ward

EXHIBITION CATALOGS

Howardena Pindell's "Autobiography"—Garth Greenan Gallery, New York (2019)

Titus Kaphar's "UnSeen: Our Past in a New Light"—Smithsonian Museum, National Portrait Gallery (2019-2020)

Nate Lewis's "Latent Tapestries"—Fridman Gallery (2020)

Chapter 2

Adams, Derrick. Personal Interview. 13 Nov. 2019.

Cox, Renee. Personal Interview. 26 Feb. 2020.

Kebebe, Alitash. Personal Interview. 15 Sept. 2019.

Moore, Charles. "Norman Lewis, whose depiction of an American tragedy, American Totem, leaves you lingering and debating the highly political aspects of this work."

Arte Fuse, 12 Oct 2019, www.artefuse.com/2019/10/12/
norman-lewis-whose-depiction-of-an-american-tragedy-
american-totem-leaves-you-lingering-and-debating-the-
highly-political-aspects-of-this-work/
Moore, Mario. Personal Interview. 8 Apr. 2020.
Pindell, Howardena. Personal Interview. 20 Dec. 2019.

Chapter 3

Go research

Chapter 4

Kebebe, Alitash. Personal Interview. 9 June 2020.

Chapter 5

www.artbasel.com
www.tefaf.com

Chapter 6

Sikelianos-Carter, Alisa. Personal Interview. 3 May 2020.
Turner, Khari. Personal Interview. 31 May 2020.

Chapter 7

Musa, Anwarii. Personal Interview. 1 May 2020.
Simone, Alaina. Personal Interview. 29 Apr. 2020.

Chapter 8

Chambers, Dominic. Personal Interview. 14 Jul. 2020.

Chapter 9

www.christies.com
www.sothebys.com
www.swanngalleries.com/

Chapter 10

Go research

Chapter 11

Harper, Hill. Personal Interview. 2 May 2020.

Chapter 12

Anonymous Collector. Personal Interview. 3 May 2020.

Chapter 13

Adams, Audrey. Personal Interview. 13 May 2020.
Maillian, Lauren. Personal Interview. 4 May 2020.

Chapter 14

McKinley, Catherine E. Personal Interview. 2 May 2020.

Chapter 15

Rivers, Keith. Personal Interview. 7 May 2020.

Chapter 16

Robinson, Craig. Personal Interview. 20 May 2020.

Chapter 17

Nieves, Elan. Personal Interview. 13 June 2020.

Chapter 18

Taylor, Everette. Personal Interview. 13 June 2020.

Chapter 19

Williamson, Virginia. Personal Interview. 3 July 2020.

Chapter 20

Lyles, Ernest. Personal Interview. 12 August 2020.

Chapter 21

Twigg, Jonna. Personal Interview. 19 May 2020.
Stone, Christian. Personal Interview.

Afterword

Want to hear more? Find me:
Instagram: @csmoore23 @champagneandvitamins
charles.moore662@gmail.com

Index

Black Rock Senegal 81
Blake, Eubie 41
Blaxploitation 54
Bloomberg News 56, 176
Boafo, Amoako 69, 146
Bodega Run 47
Boghossian, Skunder 64

Boston University 23
Bradford, Mark 7, 79
Brainwash, Mr. viii
Braque 52
Breslin, David 13
Brooklyn Museum xi, 36, 46, 176
Brown, John 14–15, 84, 89–90

C

California Institute of the
 Arts xi, 79
Cartwright, Deborah 150
Casualty - The Secretary of
 War Regrets 18
Catlett, Elizabeth 100
Cesnola Collection 50
Chagall 52
Chamberlain, John 60
Chambers, Dominic 95, 178
Chicago Reader 27
China: Through the Looking
 Glass 52
Christian Dior 32
Christie, James 27, 47,
 90, 103–104
Christie's 27, 47, 90, 103–104
City College 21
Clark, Ed 14, 18–19, 39, 63,
 65, 88–89, 163
Clayton, Alvin 111
Cobalt Blue Earring 69
Colescott, Robert x, 175

Columbia xi, xiii, 39,
 78–79, 81–82, 162
Columbia School of the Arts 79
Columbia University xi, xiii,
 39, 78, 81–82, 162
Combs, Sean P. Diddy viii,
 93, 176
Condo, George 8, 135
Contemporary Arts Museum
 Houston 49, 59
Cooper Cole 69
Cowans, Adger 138
Cox, Renee ix, 28–34,
 161–162, 177
CPP6 70
Crichlow, Earnest 110–111, 114
Critchlow, Somaya 119
Crite, Allan Rohan 5
Croftout, Peggy 34
Crown Point Press 70
CUNY 13
Cuvier, Georges 31

D

Da Vinci, Leonardo 29, 103
Dale Gas 60
Dali, Salvador 56
Dance of Malaga 69
Dandy Lion: The Black Dandy
 and Street Style x, 5, 176
Dash, Damon 34
Davies-Okundaye, Nike 119

de Kooning, Willem 6, 13
Dealing with the Pain Body 34
Delaney, Beauford 69, 99–100
Delmez, Kathryn 3, 176
Delsarte, Louis 123
Detroit vii, x–xi, 18–20,
 26, 44, 49, 55–56
Detroit Collects 56

CPSIA information can be obtained
at www.ICGtesting.com
Printed in the USA
LVHW081539090921
697455LV00010B/335/J